DUNDRUM

JOE CURTIS

The
History
Press
Ireland

Cover illustrations: front cover, Taney Primary School, 1938. 'The Wedding of the Painted Doll', with Mrs McCaughey in centre. (Courtesy of Taney Primary School); back cover, Leverett & Frye grocery shop, c. 1910. (Courtesy of Paul Campbell Senior)

First published 2016

The History Press Ireland
50 City Quay
Dublin 2
Ireland
www.thehistorypress.ie

The History Press Ireland are a member of Publishing Ireland,
the Irish Book Publisher's Association.

British Library Cataloguing in Publication Data.
A catalogue record for this book is available from the British Library.

ISBN 978 1 84588 888 6

Typesetting and origination by The History Press
Printed and bound by TJ International Ltd.

CONTENTS

ACKNOWLEDGEMENTS

Much information was obtained from the following organisations and their helpful staff: National Archives of Ireland (especially Brian Donnelly), National Library of Ireland, Irish Architectural Archive, Valuation Office, Dublin City Library and Archives.

Many thanks to the following individuals: Sr Charita Montgomery and Sr Una Rutledge and Sr Julie (all Notre Dame des Missions), Mildred Brannigan (Principal of Notre Dame Secondary), Gilda Sisk (Principal of Notre Dame Junior), Christopher Woods (Principal of Wesley College), Ultan Mac Mathuna and Carina Folan (Holy Cross NS), Bridget Blake (Principal of the College of Further Education Dundrum), Elizabeth Carpenter and Julie Maloney (Taney National School)), Nigel Curtin (Dún Laoghaire Library), Kathy Conlan (Airfield), Professor Harry Kennedy and Joe Scales (Dundrum Mental Hospital), John Mulvey, Lucy Donoghue and Carmel Magough and Eric Plunkett (all from Central Bank), Anne Lyng, Laura Magnier (Gort Muire), Teresa Whittington (Central Catholic Library), Ed Penrose (Irish Labour History Society), Paul Ferguson (Trinity College Map Library), Irish Railway Records Society, Niall Kerney (Burke Kennedy Doyle, Architects), Paul Campbell (Campbell's Shoe Repairs), David Tansey-Daly (Joe Daly Cycles), Paddy Gibbons, Sean Kennedy, Kathleen Kinch, Tara O'Rourke (Taney Parish Office), and last, but by no means least, Jean and Pat Staunton.

Thanks also to the clergy of different denominations, who welcomed me into their churches and allowed me to take photographs.

Photos and maps are acknowledged individually. Otherwise, photos were taken by the author.

INTRODUCTION

For many centuries, Dundrum was just a tiny hamlet, dominated firstly by the Fitzwilliam's castle and later by a mill, both of which attracted a variety of workers. A handful of nearby detached villas were occupied by wealthy families. In due course, the village became the centre of a farming community, especially dairy farming.

In 1816 a coach service ran between Dublin and Enniskerry (Powerscourt), pulled by four horses. This enabled tourists to stop at Dundrum, which had gained a reputation for healthy living, and for the quality of its goat's whey (milk), sourced from farms in nearby Goatstown.

The arrival of the train in 1854, courtesy of the Dublin and South Eastern Railway Company, between Harcourt Street and Bray, heralded the expansion of the village, with new houses and businesses. Small terraces of two-storey houses soon created a lively Main Street, with redbrick facades, slated roofs, projecting timber-bracketed eaves, and vertical-sliding timber sash windows.

Older properties were later demolished to make way for workers' cottages, called the Pembroke Cottages. Two clusters of these cottages were built in the late 1870s, one on Main Street opposite the church, and another on Ballinteer Road beside the mill. There is a stone plaque on Main Street, with the interwoven letters 'E, P, M', for Earl of Pembroke and Montgomery. The Pembroke Estate (formerly called the Fitzwilliam Estate) built these quaint redbrick cottages and rented them to artisans and tradesmen.

The ill-advised closure of the Harcourt Street railway line in 1959 probably heralded the demise of the village as a business centre.

New housing estates around Dundrum warranted the opening of the Dundrum Shopping Centre in 1971, while the nearby M50 motorway paved the way for the arrival of the enormous Dundrum Town Centre in 2005, preceded by the Dundrum by-pass in 2002, and the Luas light rail in 2004.

DUNDRUM.

DUNDRUM, a village in the parish of Taney, Rathdown barony, Dublin county, five miles S. from the General Post Office, Dublin, comprising an area of 35 acres. Population 550. It is situated at the base of the Dublin mountains, on the road to Enniskerry, and consists of one main street, containing 94 houses, chiefly cottages. In it is a Roman Catholic Chapel, a Dispensary, and National School. The Church of Taney, on Taney hill, is a handsome cruciform building. The neighbourhood abounds in richly diversified scenery, commanding fine views of Dublin bay and mountains, and is studded with numerous seats and elegant villas, the principal of which is Wickham, the seat of Leonard Bickerstaff, esq. ; and about half a mile above the village is Moreen, the seat of Manners M'Kay, esq., in whose grounds steeple races are held annually. Dundrum is recommended for the purity of its air, and in summer is much resorted to by invalids. Two or three well appointed Omnibuses ply here, to and from Dublin several times a day, besides the ordinary jaunting-car conveyances. The mail from Dublin arrives at 15 minutes past 8, A.M., and at 45 minutes past 2, P.M., and is despatched at 4, P.M.

Whiteford, Sir Geo. Anna villa, and 23 College-green

Mason, Henry J. esq. proprietor of the Dundrum mail and day coach, Summerville

Booth, W. esq. Frankfort lodge

Shade, Mr. Henry, Larchfield

Dowling, Miss, ladies' seminary, Larchfield

Curran, John, carpenter and builder, Rosemount

Warren, Charles, esq. Taneyville

Turner, Benj. builder, Taneyville

Mansfield, Wm. Annemount, & 90 Grafton-street

Wynne, Rev. P. A. Rosemount cottage

O'Neale, Mr. Edw. Read, Churchtown cottage, and 76 Aungier-street

Stanford, Rev. William Henry, Frankfort cottage

Mulvany, Wm. T. commissioner of Drainage and Fisheries, Dundrum lodge, and office of Public Works, Custom House

POST OFFICE—William Mann, postmaster

Houghton, Mr. Henry

MacDonnell, Miss, grocer and spirit dealer—coach office

Flynn, Cornelius, grocer and spirit merchant

Magrath, M. tavern

Sole, Chas. grocer and prov. dl.

Missett, Solomon, proprietor of Dundrum caravan

White, John L. surgeon, apothecary, and accoucheur

Travers, Robert, M.D.

Conway, Robt. solicitor—office, 25 Aungier-street

Depoe, Mrs.

Chambers, Robert, sol.—office, 37 Cumberland-street, N.

Bernard, Michael Charles, M.D. attending physician to the Dundrum dispensary

Anderson, Mr. John

Aurundel, Samuel, proprietor of omnibuses

Walsh, John, esq. Dundrum castle, and Rogerson's-quay

Meyler, George, esq. Dundrum house

Byrne, Thos. esq. Meadowbrook

Bickerstaff, Leon. esq. Wickham

Lloyd, Thomas T. solicitor, Farmley

Clarke, John, esq. Ashgrove

Sikes, George, proprietor Dundrum iron works

Macmullen, Robert, esq. Rockmount, and 6 Prince's-st. N.

Bomford, William, esq. Rockmount cottage

Carlisle, Hugh, M.D. Rockfield

Marmion, Francis, solic. Lakeview, and 7 Fleet-street

Mayne, John, esq. Runnameade

Maunsell, Robt. sol. Ballawley park, and 11 Merrion-sq. S.

Vacant, Greenmount cottage

Thompson, Henry, esq. Greenmount, & 13 Fitzwilliam-pl.

M'Kay, Manners, esq. J.P. Moreen

Ballinteer.

Curran, Daniel, builder, Ballinteer house

Curran, William, barrister, Ballinteer house

Fitzpatrick, George, esq. and 37 Stafford-street

Byrne, Jas. esq. & 42 James's-street

Keene, Martin, esq. and 29 Leeson-street, Lower

Purdon, Mrs. Mayfield, and 14 Denzille-street

Hatchell, George, esq. Ludford park

O'Neill, Captain Fetherston H. Hillton park

Sweeny, Abraham J. solicitor, Woodlawn

Parr, Thomas H. esq. Thornhill

Townsend, Mrs.

Churchtown.

Busby, Misses, Churchtown hse.

Vacant, Sweetmount

Burke, Mrs. Sweetmount

Wharton, John Lee, esq. Sweetmount house

Marshall, Wm. esq. M.D. Taney lodge

Jacob, Arthur, M.D. Woodville, and 23 Ely-place

Read, John William, esq. Lyndhurst

Manders, Robert, esq. Landscape

M'Kenny, John, esq. Bellfield, and 13 Beresford-place

Allen, Edw. esq. Mountain view, and Bridge-street, Upper

Blake, John, esq. Weston

——, Barren elm

Drummartin.

Linde, John H. esq. Drummartin house

Boxwell, Samuel, esq. Campfield house

Walshe, John, solicitor, Drummartin castle, & 7 Hume-st.

O'Connor, Mrs. Annemount, & 14 Kevin-street, Lower

Scully, Thos. M. esq. Airfield

Finlay, Misses, 1 Campfield-ter.

Hone, Henry, esq. Hazlewood house

Hill, Beauchamp B. esq. Hollywell

Crawford, Mrs. Bellevue

Taney-hill.

Hayes, Mrs. Annafield

Saunders, Edwin, esq. Annafield

Bourne, Walter, esq. and 17 Harcourt-street

TANEY CHURCH

Windy-arbour.

Bibby, William, esq.

Smith, Capt. Robert

Mitchell, Mr. George, and 10 Grafton-street

4 E

Thoms Directory. 1846. (Courtesy of Dublin City Library and Archives)

1

LAW AND ORDER

DUNDRUM CASTLE, BALLINTEER ROAD

In the Civil Survey of 1654-56, Dundrum and Ballinteer were occupied by Colonel Oliver Fitzwilliam, an 'Irish Papist'. The site comprised 500 acres and had one slated castle, barn, garden and small orchard. Ballally was occupied by James Walsh, Irish Papist, and comprised 220 acres, with one thatched castle and the walls of a chapel. Churchtown, 88 acres, was partly occupied by John Kempe, English Protestant, while William Usher, English Protestant, had 60 acres and Maurice Archbold, Irish Papist, had 95 acres in Kilmacud.

The Fitzwilliams owned large tracks of land, stretching from Merrion Square out to Blackrock, and inland through Dundrum up to Ticknock, all protected by various castles, including one at Merrion Strand (called Thorncastle), and another in Dundrum. Dundrum Castle was built in the thirteenth century, and rebuilt around 1590.

Ball, in his parish history of Taney, notes that Austin Cooper records Dundrum Castle being occupied and in excellent repair in 1780. In Archer's Survey of 1801, there is no mention of the castle. Lewis, in 1838 says only one tower remains, in ruins. The ruined castle was bought in 1987 by a private individual, in the hope of restoring it eventually.

A new castle (in reality, a large two-storey house) called Dundrum Castle House was built nearby in the 1760s, leaving the old castle for ancillary uses. Even in recent times, various companies used the building for offices. This was demolished around 1997 to make way for a block of apartments.

Frankfort Castle in Frankfort Park is a mid-nineteenth-century castellated house, split into two houses in the mid-1950s.

Drummartin Castle on Kilmacud Road was another Victorian house, demolished in recent decades to make way for a block of apartments of the same name.

GARDA STATION, KILMACUD ROAD

The Ordnance Survey map of 1837 shows a police station immediately to the north of the Manor Mill House (the latter is now the Roly Saul restaurant). The street directory for 1850 records a Petty Sessions Courthouse in Dundrum (possibly in the police station or nearby), and Manners McKay of Moreen House as one of the magistrates. The court sat every alternate Monday in later years.

A new Petty Sessions Courthouse and Irish Constabulary barracks were built in 1856, both at the corner of Eglington Terrace and Kilmacud Road, to a design by Deane and Woodward. The Irish Constabulary were given the prefix of 'Royal' after the Fenian Rising of 1867. The barracks was burnt out in the War of Independence in 1921, and rebuilt in 1927 for use by the newly created Garda Síochána. In the 1970s the Garda station was demolished and replaced by a bland modern building, while the former courthouse was used by the detective division in the 1990s. A new Garda station was built on the same site in 2015, while still retaining the former courthouse.

The 1901 Census recorded six staff residing in the RIC barracks, comprising a head constable, two sergeants, and three constables, all Catholics. In the 1911 Census, five constables were resident, and presumably the higher officers resided elsewhere in the village.

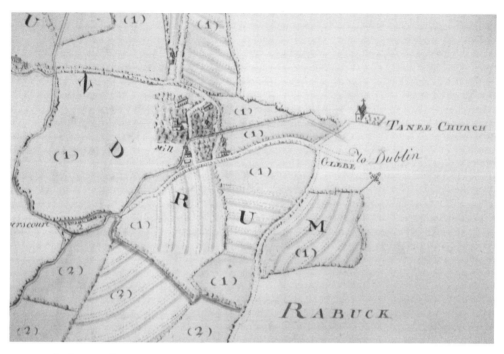

Barker's map of 1762, showing part of the Fitzwilliam Estate (after 1833 called the Pembroke Estate), including the mill, waterwheel, cattle pound, Dundrum Castle, and St Nahi's church and graveyard. (Courtesy of the National Archives)

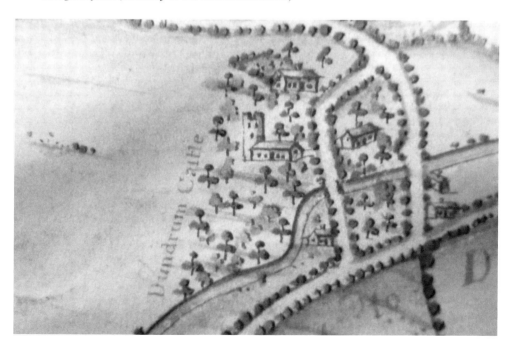

Barker's map of 1774. The tower castle is the main focus. The River Slang is prominent, although the mill waterwheel is omitted. (Courtesy of the National Archives)

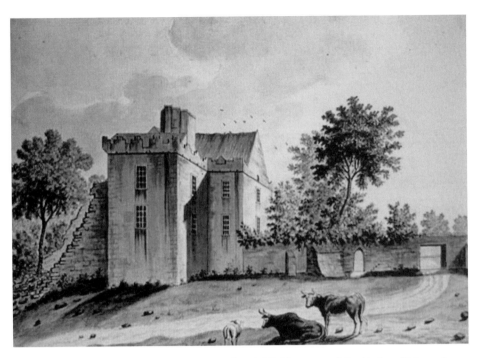

Gabriel Beranger's painting of Dundrum Castle, 1765. (Courtesy of the National Library)

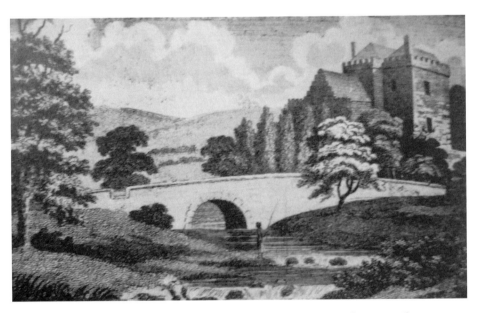

Dundrum Castle in 1802, as depicted by Ball writing in 1905. The River Slang is very prominent here. The single-arch stone bridge was recently replaced with the Dom Marmion bridge. (Courtesy of Dublin City Library and Archives)

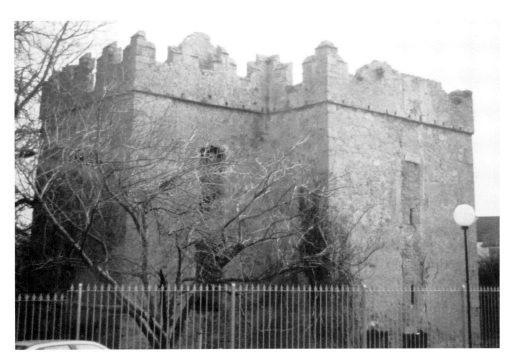

Dundrum Castle in 1999 as seen from the car park of Dundrum Castle House apartments. The disused castle is now privately owned.

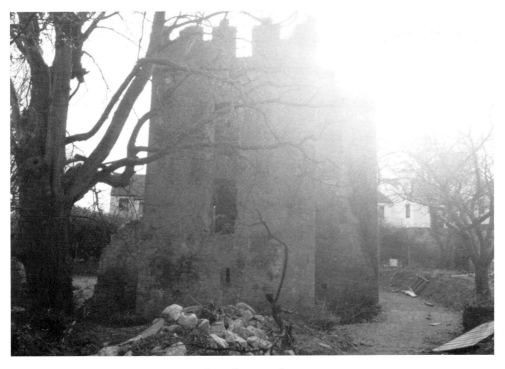

Dundrum Castle in 1999, as seen from the east side.

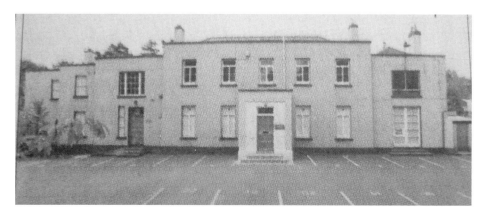

Dundrum Castle House in the 1980s was divided into various offices. The house was later demolished and replaced by a small block of apartments, also called Dundrum Castle House. (Courtesy of the Irish Architectural Archives)

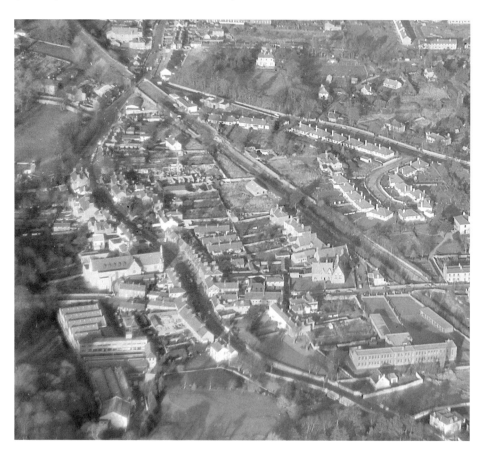

An aerial view of Dundrum, 1964. The Pye Centre and mill pond can be seen in the lower left-hand corner of the photograph. The old Garda station is alongside the courthouse on Kilmacud Road, opposite Holy Cross National School. (Courtesy of the National Library of Ireland)

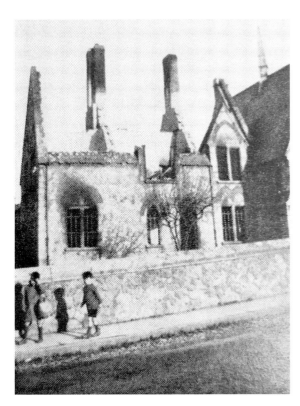

The burnt-out Royal Irish Constabulary (RIC) barracks on Kilmacud Road after the War of Independence. The adjoining courthouse was not damaged. (Courtesy of Christ Church Taney Select Vestry)

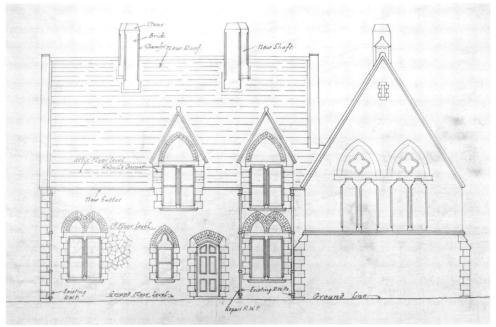

Front elevation drawing for the reinstatement of the former RIC barracks in the late 1920s. The gable wall of the courthouse is on the right. (Courtesy of the Office of Public Works)

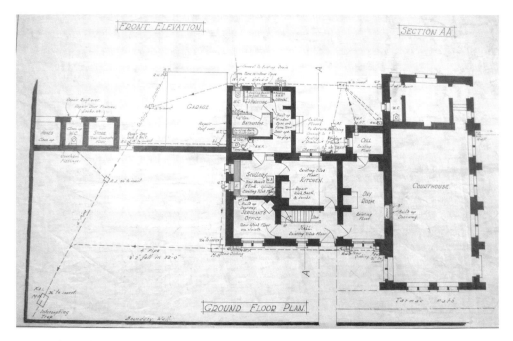

Ground-floor plan for the reinstatement of the former RIC barracks as a Garda Síochána station in the late 1920s. (Courtesy of the Office of Public Works)

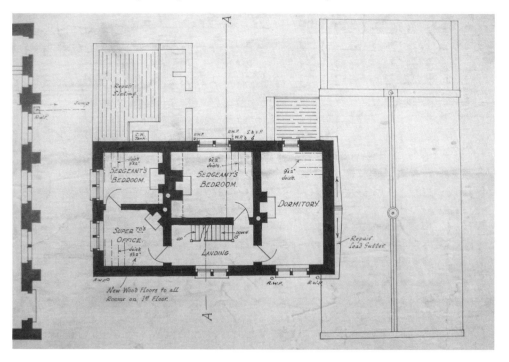

First-floor plan for the reinstatement of the former RIC barracks as a Garda Síochána station in the late 1920s. This level contained a dormitory for gardaí, and two bedrooms for sergeants, plus a superintendent's office. (Courtesy of the Office of Public Works)

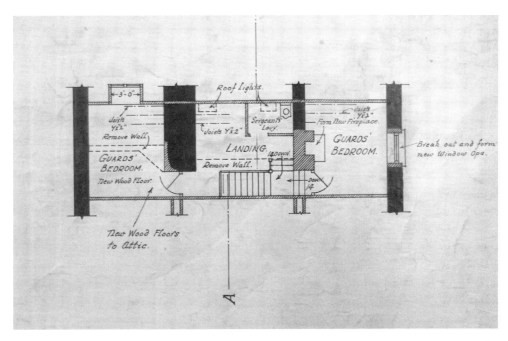

Attic floor plan for the reinstatement of the former RIC barracks as a Garda Síochána station in the late 1920s. This floor contained two bedrooms for gardaí. (Courtesy of the Office of Public Works)

Philip and Jeremy Emmet, descendants of Robert Emmet, at a bi-centenary commemoration in 2003, at Casino House, Dundrum Road, which was previously owned by the Emmet family.

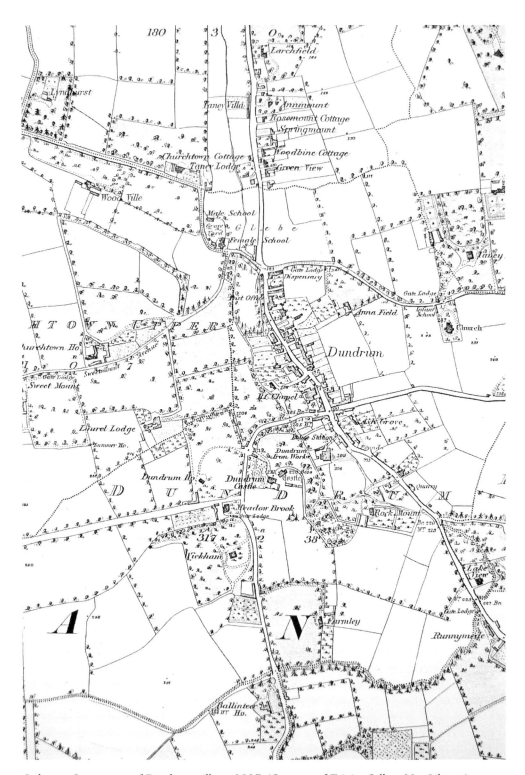

Ordnance Survey map of Dundrum village, 1837. (Courtesy of Trinity College Map Library)

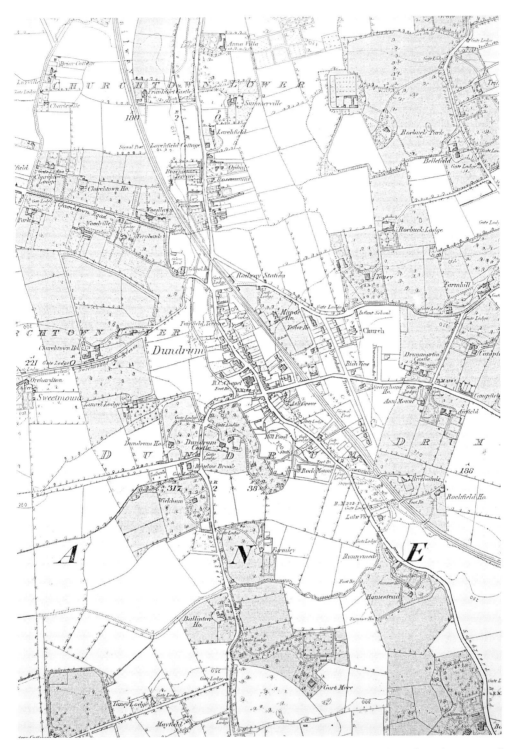

1869 Ordnance Survey map of Dundrum village. Note the new railway line. (Courtesy of Trinity College Map Library)

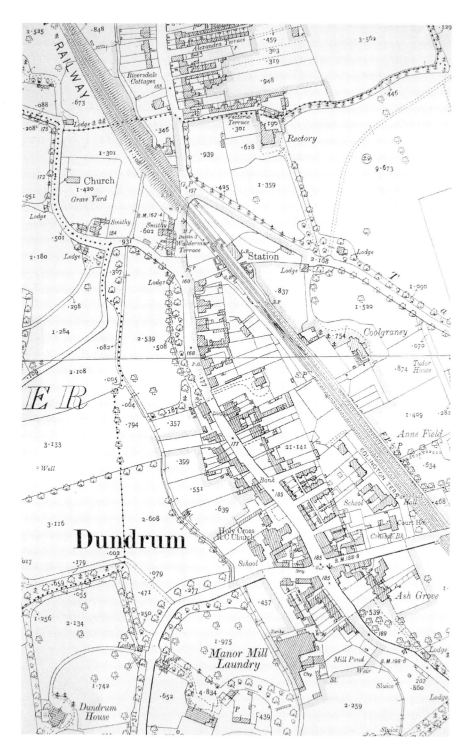

1907 Ordnance Survey map of Dundrum village. Holy Cross National School is the building behind Holy Cross church. (Courtesy of Trinity College Map Library)

2

EDUCATION

NOTRE DAME DES MISSIONS SCHOOL, CHURCHTOWN ROAD UPPER

This order of teaching nuns was founded in Lyon, France, in 1861 by Euphrasie Barbier. They had many branches in England, where Irish girls went, but it wasn't until the 1950s that a community was founded in Ireland.

Catholic Archbishop John Charles McQuaid did not like living in his palace in Drumcondra, and so he bought a large and secluded mansion on the Military Road in Killiney, County Dublin, called Ashurst, and he renamed it Notre Dame des Bois – Our Lady of the Woodlands. In 1952 he invited three Irish nuns from England back to Ireland to look after the domestic arrangements in his country retreat. In January 1953, the archbishop sent these three nuns to Churchtown to start a girls' school, in a mid-Victorian house called Fernbank, where eight young girls were taught in the front parlour. The east parlour became the nuns' chapel. Within a few years the community comprised Sisters Annunciation Ducie (school principal), Philomena McAlea, Flora O'Dwyer, Conleth Kelly, Lelia Flanagan, Rose Martin (Paschal), Mel Kavanagh, Catherine O'Brien (Kieran), and Mother Anna Marie Redmond.

They built a new two-storey school (later used as the convent) alongside the old house, and also acquired a neighbouring property called Woodville – the early Victorian house has the appearance of having been either rebuilt or doubled in height in the Edwardian era. One of the original three nuns was Sr Anna Marie Redmond, related to John Redmond MP, and a memorial stained-glass window to the Redmond family originally graced their parlour chapel in the old convent, but it was re-installed in 2008 in their new convent chapel opposite St Nahi's church entrance.

In 1958 an imposing new two-storey National School was opened in the space between the two old houses, beautifully designed by Richard Guy and Patrick Moloney of O'Connor and Aylward, and built by Hugh O'Neill & Co.

A new single-storey primary school opened in 1975 to the south of the 1958 building (by this stage used as the secondary school), which was replaced by the present building in 2009 at the south-west corner of the campus (after which the 1975 school was demolished).

The nuns suddenly withdrew from education in 2002, and the schools came under the control of a private trust, comprising nuns, teachers, and parents. Part of the land was sold to developers, and new housing is expected shortly. The nuns built a new convent in 2008 on a former hockey pitch opposite the entrance to St Nahi's church, where twenty-three nuns presently reside. The 1950s part of their old convent was demolished, leaving the Protected Structure 'Fernbank'.

ARDTONA HOUSE SCHOOL, CHURCHTOWN ROAD LOWER

Not far from Notre Dame, at the top of Churchtown Road Lower, is a lovely school called Ardtona House School, which caters for 3- to 8-year-old children. This was started in 1941 in the old house of that name, although it is shown on older maps as Lyndhurst, and later as Churchtown Lodge.

Ardtona was the property of the Herons, and at the request of the parish priest in Dundrum, Sheila (also known as Judy or Mamo) Rogerson (née Heron) set aside most of the upper floor as classrooms, while she and her husband Fred, and children, occupied the ground floor and basement. Her brother Lorcan occupied one room on the first floor. The large rear garden and tennis-courts was shared with the schoolchildren. Mrs Rogerson died in 2006, and now the school is run by Margot O'Connor, a long-standing teacher.

GORT MUIRE, BALLINTEER ROAD

Gort More (Irish for large field), a two-storey over basement mansion, was built around 1857 for Richard Atkinson, to a design by John Skipton Mulvany. A charming single-storey wood-panelled study was added in the 1880s, followed by a wonderful wrought-iron conservatory in 1897, featuring fish-scale coloured glass in the roof. The free-standing mock-medieval stone tower, used to house a water tank, may date from the time of these extensions.

The Carmelite priests bought the house and 50-acre farm in 1944, for use as their novitiate, and renamed it Gort Muire (Mary Field). The large chapel/oratory was added in 1948, with a Sean Keating painting in the apse entitled 'The Scapular Vision'. In bygone days, the large walled garden was a special feature of the property, but gradually it was abandoned.

In recent years, parcels of land have been sold to housing developers, and the days of Gort Muire are probably numbered.

The Carmelites are mostly associated with Whitefriar Street church, and Terenure College.

WESLEY METHODIST COLLEGE, BALLINTEER ROAD

John and Charles Wesley founded the Methodists in England in 1739, fourteen years after John was ordained an Anglican priest. Their Christian message spread throughout Ireland in the following decades.

Wesley College boarding secondary school started in an old Georgian building, 79 St Stephens Green, in 1845. Playwright George Bernard Shaw was a reluctant day student here in 1865-1868.

In 1879, a new school was built a short distance away, beside the recently opened Methodist Centenary church. In 1911, the school took the unorthodox step of admitting girls, although there was strict segregation between the two sexes.

Wesley College attracted quite a few Jews, and from 1930 to 1935 Chaim Herzog was a pupil here. On leaving the college he immediately emigrated to Muslim Palestine to participate in the Zionist dream of creating a new Jewish state. He spent much of his career in the defence forces, before becoming President of Israel from 1983 to 1993.

The college made the brave decision to move to Dundrum in 1964, when they purchased Ludford Park, a 50-acre farm, and initially, twenty-four senior male boarders resided here. Michael Scott and Partners (Robin Walker in particular) designed a campus-style secondary school, not unlike the newly opened UCD in Belfield, and President of Ireland, Eamon de Valera, performed the official opening in 1969. There were six two-storey blocks, separated by wide uncovered walkways: Assembly, Classrooms, Science, Gym (with outdoor heated swimming pool), Girls' Residence, Boys' Residence. The principal now occupies the old Ludford Park house. The Greek college motto still prevails: 'Prove all things; hold fast that which is good.'

The charming St Stephens Green School was demolished in the 1970s and replaced by modern office blocks, which were later occupied by accountants, Stokes Kennedy Crowley (now KPMG).

IRISH MANAGEMENT INSTITUTE, SANDYFORD ROAD

The IMI was founded by various businessmen in Dublin in 1952, with the aim of improving the standards of management in Irish industry, including organising classes for suitable employees. They initially rented offices in 81 Grafton Street, then 79 Merrion Square, before purchasing 12 Leeson Park. In 1965 they purchased 'Errigal' with 4 acres on Orwell Road.

'Clonard' (which in 1837 was called Moreen Lodge), with 12 acres on the Sandyford Road, the former home of the Myerscough family, was purchased in 1971, and the National Management Centre was opened in 1974. Arthur Gibney of Stephenson & Gibney won the RIAI Gold Medal in 1975/76 for the unusual design, which was inspired by the Oakland Museum near San Francisco, designed by Irish-American, Kevin Roche. The current concrete building is of cellular design, intended to fit into the sloping and rocky site. The original mid-Victorian 'Clonard' has been retained near the new building. The Centre has teaching facilities for 500 students, and a 400-seater restaurant. In 2002, a residential wing was added. The campus is now a peaceful oasis, with sweeping green lawns amidst many mature trees.

Their old headquarters in Rathgar was bought by the Russian Embassy in 1974.

COLLEGE OF FURTHER EDUCATION (ETB), KILMACUD ROAD, AND MAIN STREET

The Vocational Educational Committee (now called the Education and Training Board) has been active in Dundrum since 1957, when the very distinctive boys' Technical School ('tech') opened, at the corner of Kilmacud Road and

Sydenham Road. Robinson Keefe and Devane were the architects, and produced a very enlightened design for that era, featuring granite semi-circular archways around steel windows, pebbledashing plaster, natural slates, apex rooflights, etc. The south-west hall included a concert stage.

In 1967, the local girls were provided with a secondary school on Main Street, although a lower budget resulted in a very utilitarian design. The Main Street site was previously occupied by a small Victorian house called Lauristinus, which the VEC demolished a few years previously. The girls' school only provided education up to Junior Certificate level. 'Techs' were the equivalent of secondary schools, but concentrated on more practical or technical skills, instead of academic subjects. There was a certain snobbery adopted by secondary schools, although the 'techs' were in fact the backbone of the economy.

In 1986, the girls' secondary school and the boys' 'tech' amalgamated into a secondary school, under the title Dundrum College, based at the Sydenham/ Kilmacud Roads site, providing co-education up to Leaving Certificate level. In addition, the building on Main Street became the College of Commerce, providing post-Leaving Certificate secretarial courses for girls. From 1996, it also provided education for mature students, and then changed its name to the College of Further Education in 2003.

In 2009, the secondary school on Sydenham/Kilmacud Roads closed, and since then has provided adult and further education.

TANEY PROTESTANT NATIONAL SCHOOL, SYDENHAM VILLAS

The school is reputed to have been in existence from at least 1782, probably in St Nahi's church itself or in a cottage in the vicinity of the church. Archers Survey of 1801 records Henry Curran as the schoolmaster, and Matthew Campbell as the curate, with no glebe (priest's house).

After the new church opened on Taney Hill in 1818, part of St Nahi's church was used as a boys' school, while the other part was still used for funeral services because of the graveyard alongside. The girls' school was at the foot of the graveyard, probably in the present Peach Cottage. An infants' school was built on the west side of the forecourt of Taney church (as shown on the 1837 OS map).

In 1859, a new two-roomed school, and master's residence, was opened in Eglington Terrace, designed by Deane & Woodward. Another classroom and toilets were later added at the rear of the school, resulting in a T-shaped building. In 1898 a parochial hall was built abutting the south end of the school, to a design by J.F. Fuller, and this doubled-up as extra classrooms for the school – a large stone plinth carries the date 1897.

A new school was opened in nearby Sydenham Villas in 1970, extended in 1994, and now caters for about 240 boys and 210 girls. The old school and hall in Eglington Terrace continued to be used by Taney parish for social activities until 1989, and then sold for commercial use. These days the old parochial hall is used by HOPE Baptist church, a Christian community, while the old school and master's residence is in office use.

HOLY CROSS CATHOLIC NATIONAL SCHOOL, KILMACUD ROAD

The original boys' school started in 1826 in a single-storey building adjoining the north transept of the chapel on Main Street. It was 39ft by 15ft and built to cater for around 150 boys. The girls' school started in 1827 in a similar-sized building adjoining the south transept of the chapel. (Most old maps show Catholic places of worship as 'chapels' and Anglican places of worship as 'churches'. Methodists and Presbyterians were also denoted as chapels, since they were not part of the Established Church (Anglicans).)

The school joined the National School system on 17 April 1832, with Abraham McMahon as the master at a salary of £30 a year, and Catherine Pollard as the mistress, at £20 a year. The two schools were struck off the rolls on 16 April 1834, and restored on 9 July 1835, on condition that two walls were built to separate the schools from the chapel. The Education Board was still asking for the walls to be built in 1839! In 1841 the girls' school applied for an assistant teacher, Mary Ann Pollard, aged 16, the daughter of the mistress. An application for a different assistant was made in 1855, Mary Mulvey, aged 17. Around this time, the boys' school was run by Charles Eardley at £32 a year, an assistant, John O'Callaghan, aged 15, and a monitor, Thomas Mulvey, at £5 a year. The monitors were older children who taught the younger children, free of charge, although the school could claim a small salary from the Education Board in Marlborough Street. This practice continues unofficially to this day in rural areas.

One year before the rebuilding of Holy Cross church was completed in 1878, a new detached T-shaped boys and girls National School was provided at a lower level in the steeply sloping yard to the west of the church, designed by John Loftus Robinson, and built by local man, William Richardson. George Coppinger Ashlin was the architect for the new church and Meade was the builder. Presumably, temporary accommodation was provided nearby for the pupils while their new school was being built.

In the 1930s and '40s the school was bursting at the seams, and some classes were held on the first floor of the Carnegie Library at the other end of the village, and also in the courthouse beside the Garda station. A fire in the school in 1942 only made the situation worse. In 1944, a new National School was built on nearby Kilmacud Road, opposite the Garda station, with the girls on the ground floor and the boys on the first floor. A major extension was added in 1979, which became the girls' section, but boys and girls were amalgamated in 1987. Nowadays there are around 233 pupils.

The 1956 west extension of the church on Main Street was built on the old school site, after the former classrooms were demolished.

AIRFIELD, OVEREND WAY AND KILMACUD ROAD

Airfield was a small house built in the 1820s, but enlarged a few decades later. In 1894, solicitor Trevor Overend and his wife Lily bought the small property as a holiday home, but adopted it as their main home.

The Overends had no sons to inherit the property, so their two single daughters, Letitia and Naomi, took over the farm when the parents died, and became famous for their herd of cream-coloured Jersey cows. Letitia was well-known for her lifelong

ownership of a 1927 Rolls-Royce, which she serviced herself. Naomi had a 1936 Austin Tickford.

The two sisters set up an educational trust in the 1970s, which carried on after the two sisters died – Naomi was the last to die in 1993. The trust now runs an important tourist attraction on 38 acres, with the old house used as an interactive museum, telling the story of the Overend family, especially the two colourful sisters. Many new buildings have been erected by the trust in recent years, to create a mini working farm, including Jersey cows, sheep, goats, pigs, hens, and bees. The lovely walled garden and vegetable garden are full of colour and variety, and there is a restaurant and cafés.

CARNEGIE LIBRARY, NEAR DUNDRUM STATION

Andrew Carnegie rose from humble beginnings in Scotland to become a very wealthy American industrialist. In his later years, he set up a trust to distribute his money for library building in many countries. Ireland built many libraries in the first decade of the twentieth century, all of different size and design, substantially funded by the Carnegie Trust.

Dundrum came late to the table in 1914, and architect R.M. Butler provided a modest but spacious design. A first-floor rear extension was added in recent decades, on top of the original three-bay annex.

The library was a multi-purpose venue in its early years, with regular concerts on the first floor, and even the Holy Cross National School used it for extra classrooms prior to the opening of their new school in 1944.

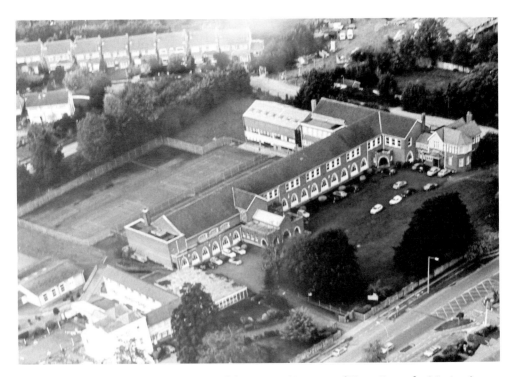

Aerial photo of Notre Dame Schools around the 1980s. (Courtesy of Notre Dame des Missions)

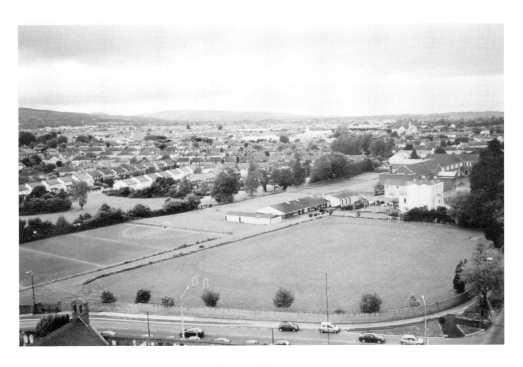

Above and below: Notre Dame Schools in 2002.

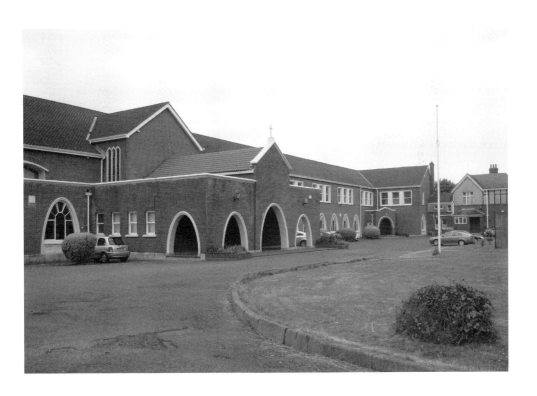

A recent photo of the convent of Notre Dame Schools. This house was originally called 'Fernbank'. The main house is still standing, but not the smaller side building. (Courtesy of Notre Dame des Missions)

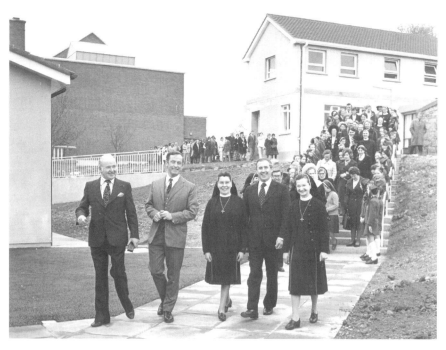

The opening of a new single-storey primary school at Notre Dame, 12 June 1975. From left to right: -?-, -?-, Sr Miriam Bambrick, Minister for Education Dick Burke, Sr Dympna. (Courtesy of Notre Dame des Missions)

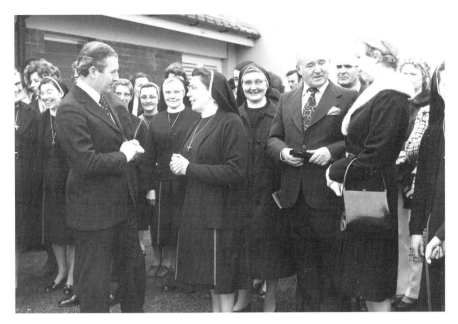

The opening of the new primary school at Notre Dame, 1975. From left to right: Sr Julie, Thelma Gallagher, Sr Paula, Dick Burke, Sr Patricia Corcoran, Sr Rupert Jones, Sr Marie, Sr Joseph Dennehy, -?-, Mrs O'Dalaigh (wife of President Cearbhall O'Dalaigh), Sr Dympna. (Courtesy of Notre Dame des Missions)

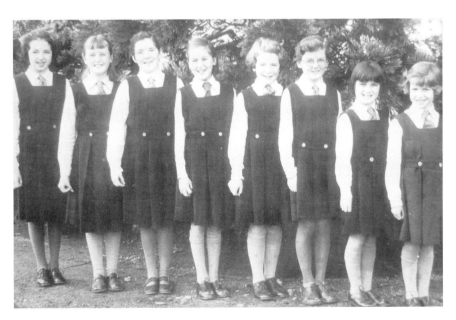

The first Notre Dame pupils, in 1952, were, from left to right: Maura McArdle, Patricia Daly, Ann Nolan, Diane Barfield, Jill Vaughan, Roisin and Joan Fitzgerald, Ann Boylan. (Courtesy of Notre Dame des Missions)

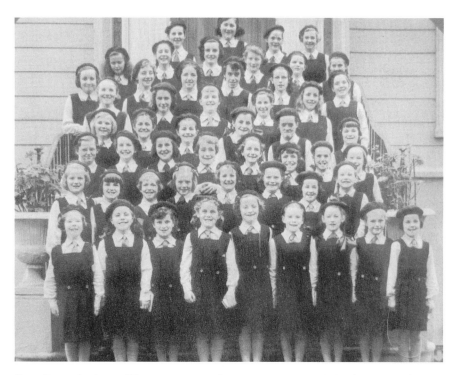

Notre Dame Senior and Junior group on the convent steps in 1953. (Courtesy of Notre Dame des Missions)

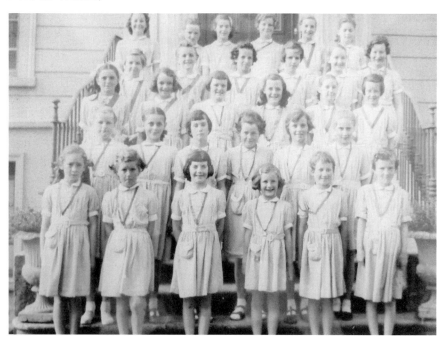

Notre Dame girls on the steps of the convent in 1955. (Courtesy of Notre Dame des Missions)

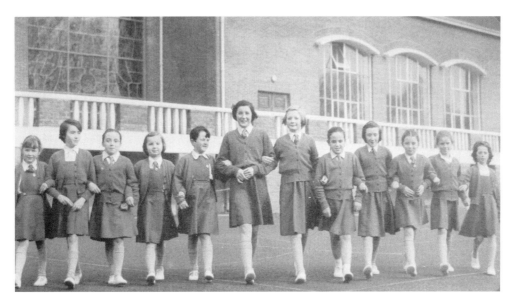

Notre Dame pupils with a stained-glass window in the background, late 1950s. (Courtesy of Notre Dame des Missions)

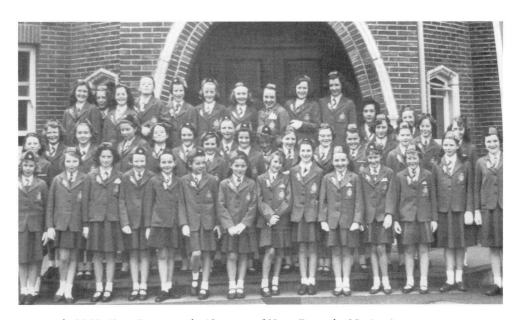

Early 1960s Notre Dame pupils. (Courtesy of Notre Dame des Missions)

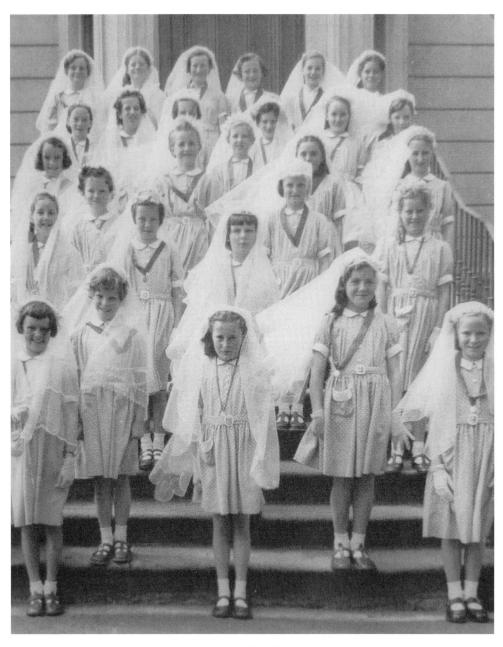

Notre Dame First Holy Communion girls, pictured on the convent steps, 1960s. (Courtesy of Notre Dame des Missions)

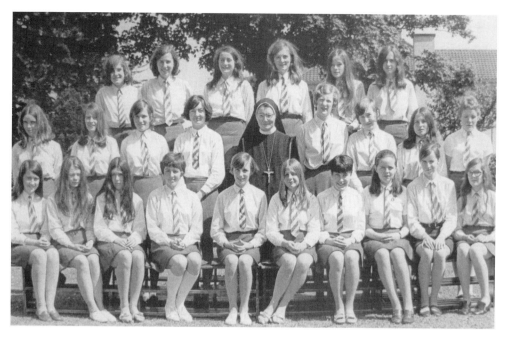

Notre Dame Leaving Certificate students with Sr Christopher, 1971. (Courtesy of Notre Dame des Missions)

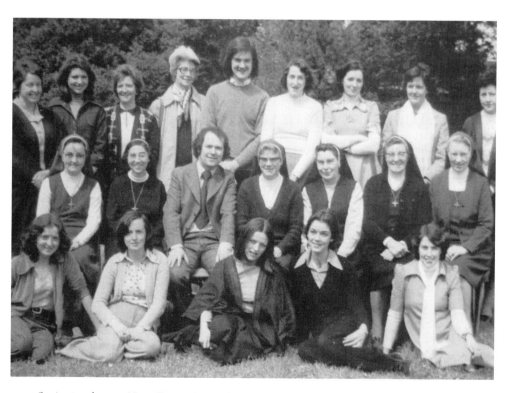

Senior teachers at Notre Dame, 1975. (Courtesy of Notre Dame des Missions)

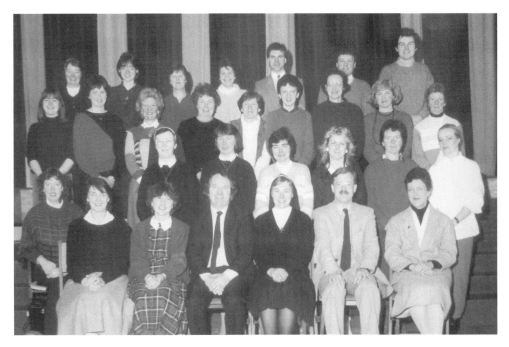

Senior teachers at Notre Dame in 1986. (Courtesy of Notre Dame des Missions)

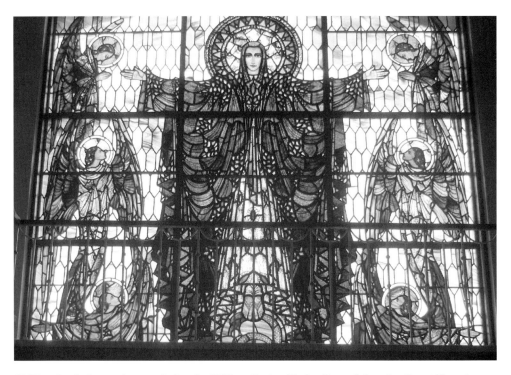

1958 stained-glass staircase window by William Earley (Earley Bros of Camden Street Upper) in Notre Dame.

Ardtona House Infant School, Lower Churchtown Road.

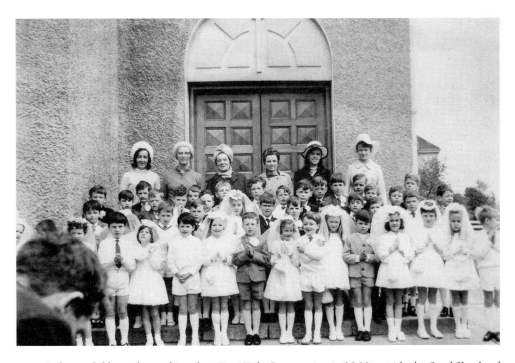

Ardtona children after making their First Holy Communion in 1969 outside the Good Shepherd church, Churchtown. The principal, Mrs Rogerson, is third from left at rear. Her sister, Ann McDonagh, is fourth from left. (Courtesy Paul Flynn/Ardtona House School)

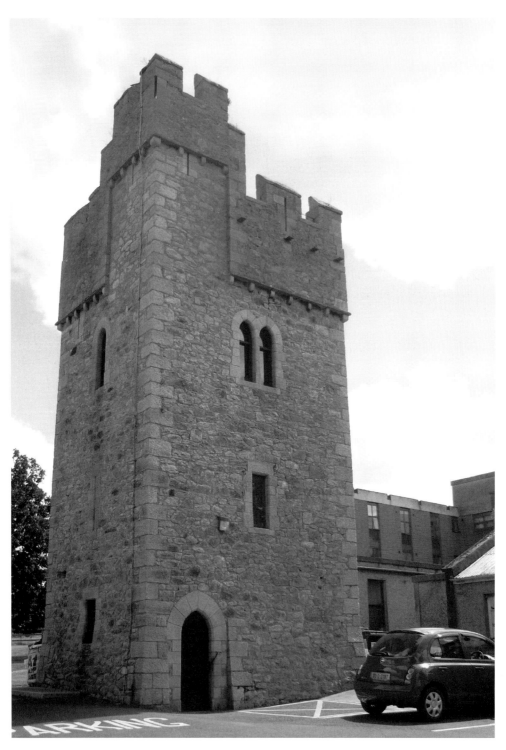

A recent photo of the mock-medieval tower house in Gort Muire. This is actually a water-tower built in the 1880s.

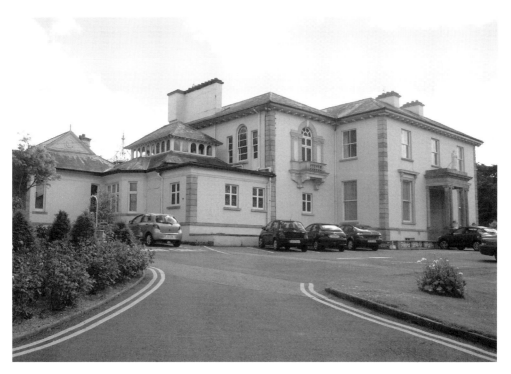

A recent photo of Gort Muire, built around 1857, but extended two or three decades later.

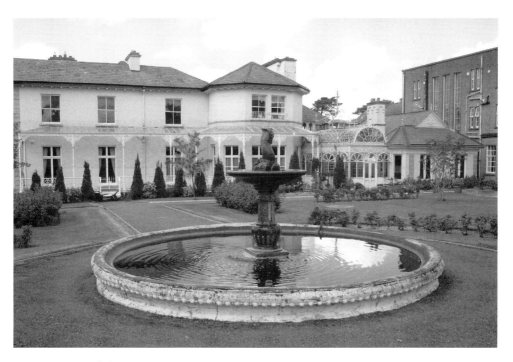

Rear view of Gort Muire.

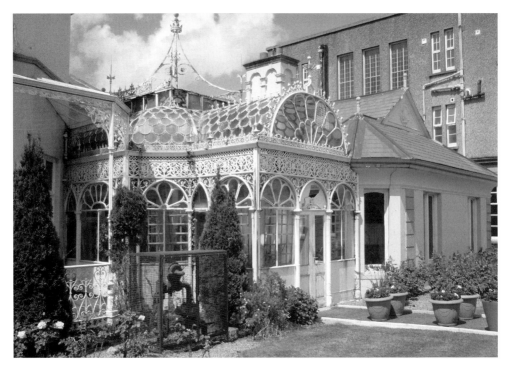

Gort Muire's ornate conservatory probably dates from the 1880s.

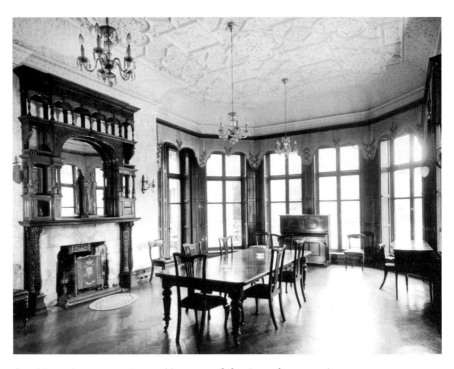

Gort Muire Community Room. (Courtesy of the Carmelite priests)

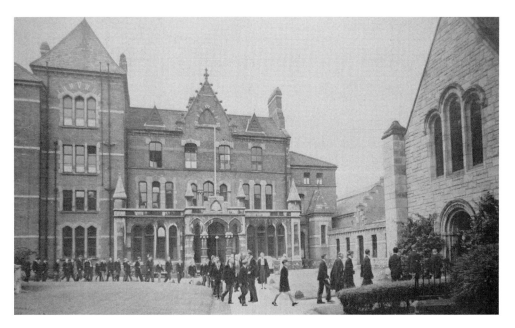

Wesley College in St Stephens Green. The college had its own chapel on the right. It is now the site of modern office blocks occupied by KPMG. (Courtesy of National Archives)

Wesley College, St Stephens Green, 1964. (Courtesy of Wesley College)

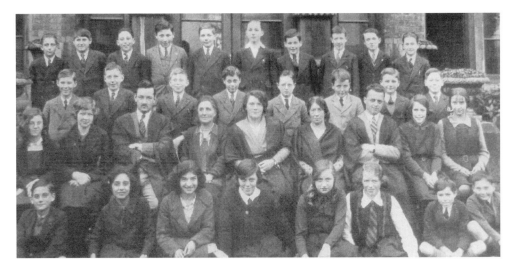

Wesley College, 1931/32. Front row, from left to right: Reginald Gould, Madeline Isaacson, Hilary Gruson, Irene Calder, Mabel Leary, Merle Alford, -?-, John Marks. Second row: Beatrice Cairns, Carda Landsay, Mr Munro, Miss Guilgault, Miss Smyth, Miss Kissane, Mr McDowell, Helen Hadden, Ella Houston. Third row: George Parker, Brian Gilliand, Chaim Herzog, Eric Levinson, Eric Whiteside, Basil Booth, Arthur Cope, Walter Hunter. Back row: -?-, Maurice Weiner, Harold Robinson, Nathan Jacobs, Billy Ashmore, Harry Stuart, John Harrison, John Wilkes, William Seeds, Victor Tyrrell. (Courtesy of Wesley College)

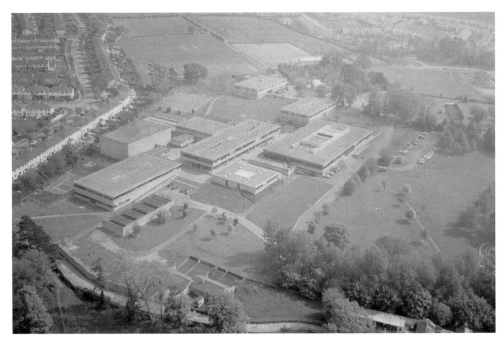

1993 view of Wesley College, Ballinteer. The open-air swimming pool is visible behind the tall block on left side. (Courtesy of Wesley College)

Classroom block at the Wesley College, 1993. (Courtesy of Wesley College)

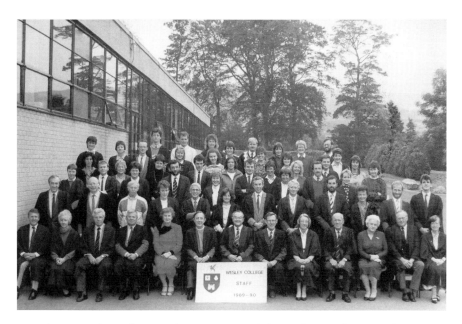

1989/1990 Wesley College teachers: Front row, left to right: A. Edge, I. Reed, G. Eagar, E. Byran, E. Byrne, G. Hamilton, K. Blackmore, E. Armitage, M. Cooke, F. Morrison, V. Barrett, R. O'Connor, M. Sheehan. Second row: D. Rice, F. Hughes, D. Kennedy, E. Vogan, R. Richie, G. Mullally, J. Leeson, S. Austen, M. Halliday, R. Price, B. Duffy, P. Murphy. Third row: E. Corcoran, N. Mac Monagle, F. Meehan, S. Kingston, B. Gillmor, C. Drury, R. Henderson, P. Lewis, D. Lewis, E. O'Connor, E. Heffernan. Fourth row: M. Bushe, M. Milne, J. O'Connell, R. Garland, L. Tallon, B. Kenevey, G. Darlington, L. Downer. Fifth row: M. Wynne, S. Cooke, S. O'Braonain, M. Hill, M. Dinn, G. O'Connor, D. Kingston, G. Bannister. Rear row: B. Delany, D. Conway, D. O'Connell, A. Graham, F. O'Bien, M. Garvin, J. Blackmore, P. Scott. (Courtesy of Wesley College)

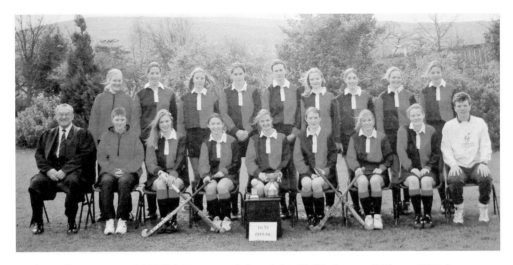

Wesley College, First XI, 1993/94. Front row, left to right: Mr Blackmore, S. Flynn, W. Hobson, C. Filgate, K. Bowers (Captain), J. Black, S. Stewart, R. Prichard, Mr Madeley. Back row: B. Sheehy-Skeffington, N. Campbell, D. Kelly, C. Johnston, S.J. Lawson, T. Greenlee, V. Jones, S. Young, J. Cole. (Courtesy of Wesley College)

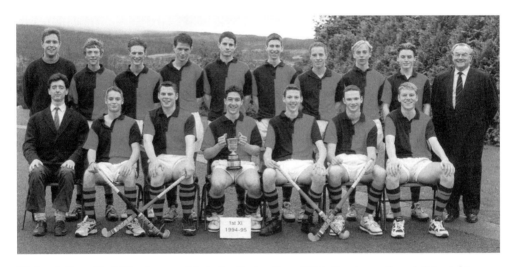

Wesley College, First XI, winners of Leinster Senior Cup, 1995. Front row, from left to right: Mr B. Delany, R. Priestman, C. Deane, J. Sleeman (captain), G. Dowling, K. Poynton, D. Hanna. Back row: Mr Lemon, S. Ringwood, I. Cox, P. Osborne, S. Jones, J. Harrison, M. Henderson, G. Ringwood, K. Wilkinson, Mr Blackmore. (Courtesy of Wesley College)

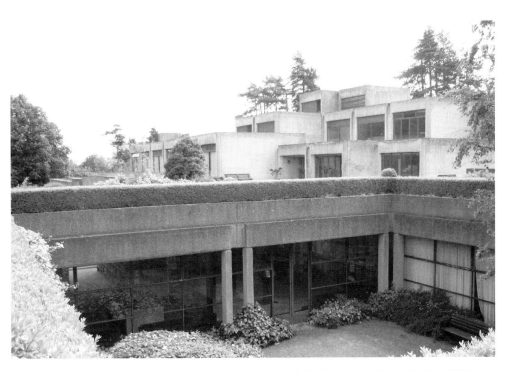

Recent photo of the Irish Management Institute, Sandyford Road, which was built in 1974 to a 'cubist' design.

'Clonard' is still on the campus of the Irish Management Institute.

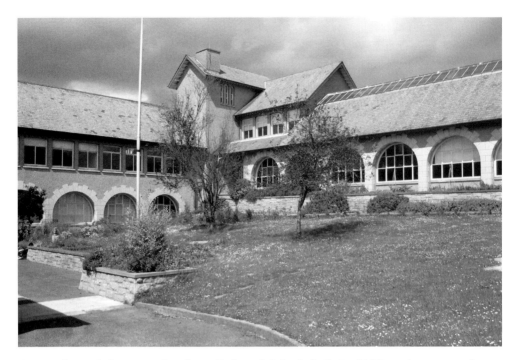

Recent photo of the iconic Dundrum Technical School, built in 1957 at the corner of Sydenham Road and Kilmacud Road.

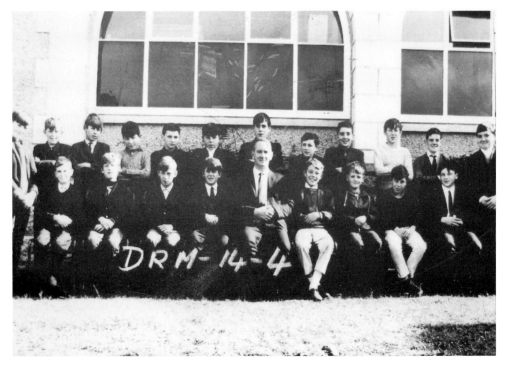

Dundrum Technical School, *c.* 1960s. (Courtesy of Dublin & Dún Laoghaire ETB)

Dundrum Technical School, *c.* 1960s. (Courtesy of Dublin & Dún Laoghaire ETB)

The Concert Hall of Dundrum Technical School, *c.* 1960s. (Courtesy of Dublin & Dún Laoghaire ETB)

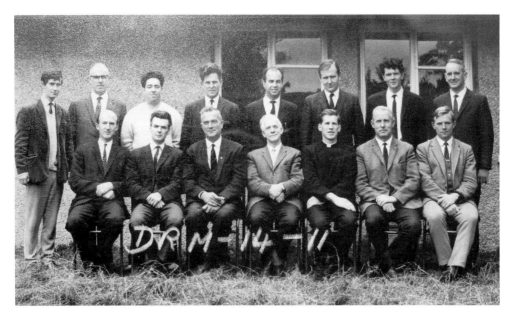

Dundrum Technical School, *c.* 1960s. (Courtesy of Dublin & Dún Laoghaire ETB)

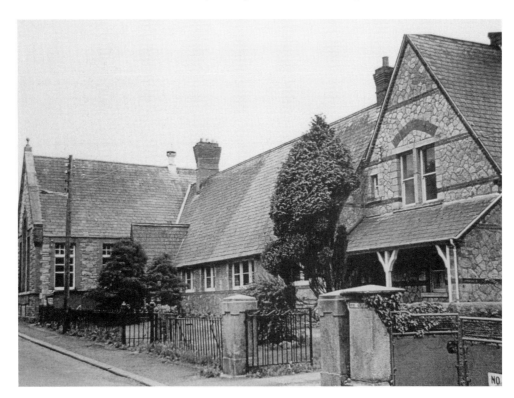

Eglington Terrace, 1994. The attached building on the left was Taney Parochial Hall, while the attached building on the right was the master's residence. (Courtesy of Judy Blain/Taney Primary School)

2004 photo of Taney Primary School, Sydenham Villas, which was built in 1970.

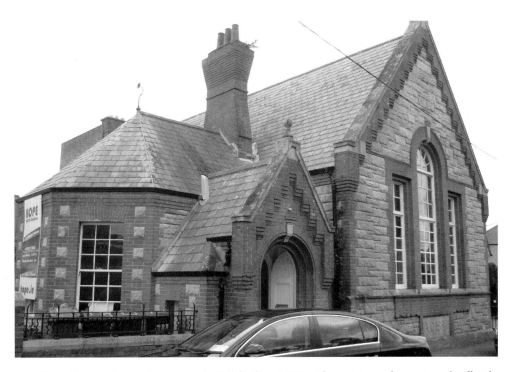

The attractive former Taney Parish Hall, built in 1898 with a mixture of granite and redbrick, is now the Hope Baptist church.

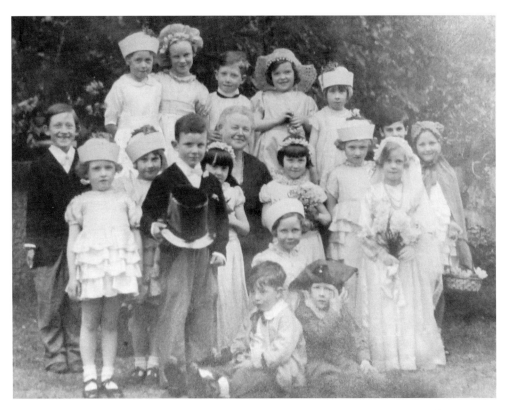

Taney Primary School, 1938. 'The Wedding of the Painted Doll', with Mrs McCaughey in centre. (Courtesy of Taney Primary School)

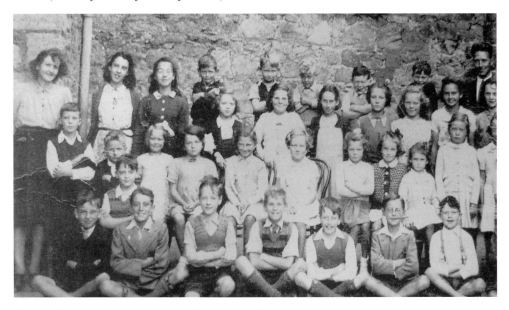

Class of 1947, Taney National School, Eglington Terrace. The entire school is congregated in this charming photo. (Courtesy of Christ Church, Taney)

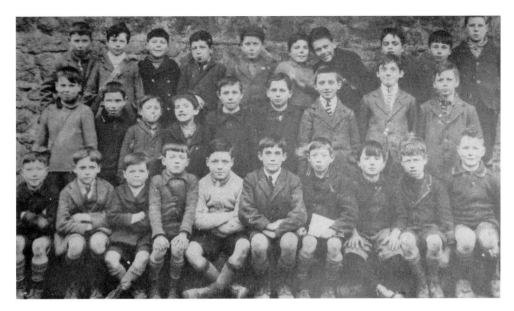

Holy Cross National School outside their detached school behind Holy Cross church on Main Street, *c.* 1926. (Courtesy of 'The Willows' pub)

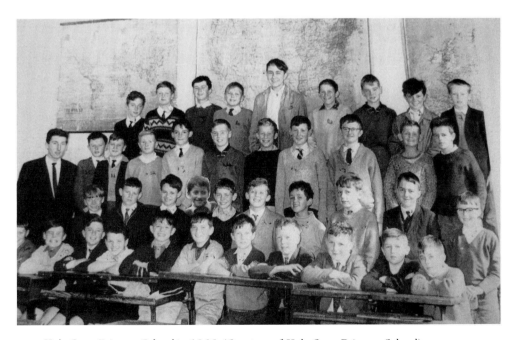

Holy Cross Primary School in 1966. (Courtesy of Holy Cross Primary School)

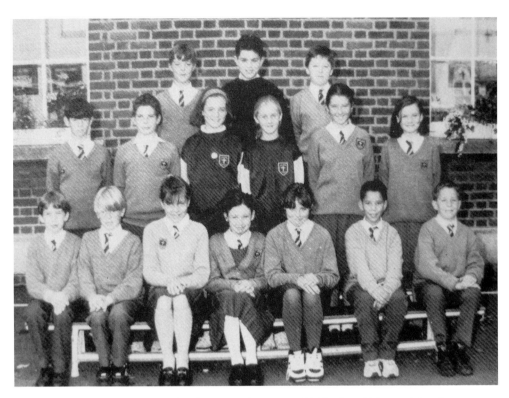

6B class in Holy Cross Primary School in 1994. (Courtesy of Holy Cross Primary School)

Holy Cross Mixed Primary School today.

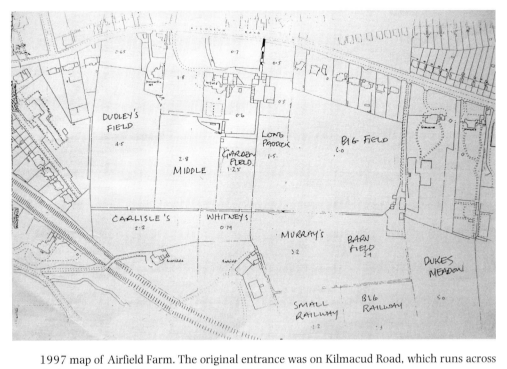

1997 map of Airfield Farm. The original entrance was on Kilmacud Road, which runs across the top of the map. (Courtesy of the Airfield Trust)

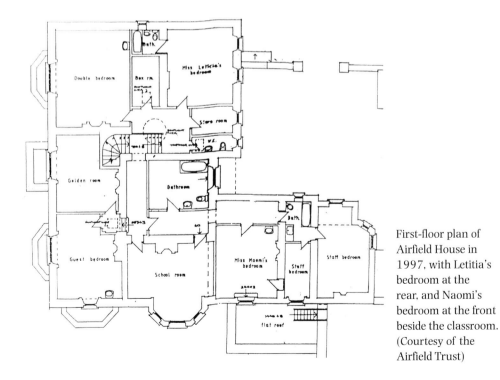

First-floor plan of Airfield House in 1997, with Letitia's bedroom at the rear, and Naomi's bedroom at the front beside the classroom. (Courtesy of the Airfield Trust)

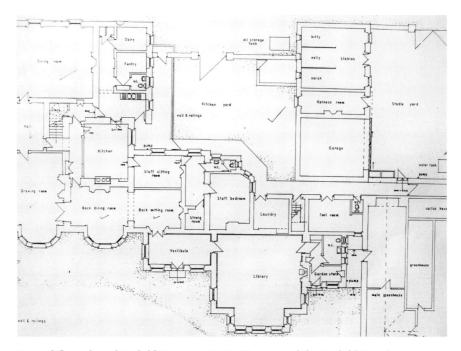

Ground-floor plan of Airfield House in 1997. (Courtesy of the Airfield Trust)

Letitia and Naomi Overend in Airfield at a gathering of the very exclusive '20 Ghost Club', after touring Ireland in their Rolls-Royce, 1971. (Courtesy of the Airfield Trust)

Letitia Overend (left) and Naomi Overend (right) in 1904. (Courtesy of the Airfield Trust)

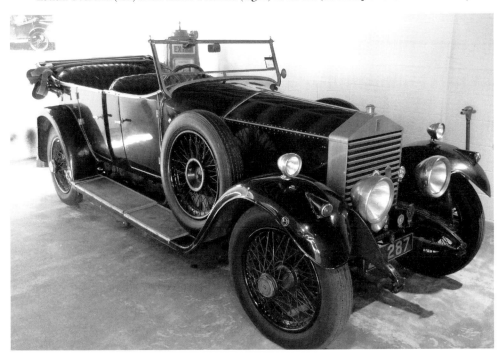

Letitia Overend's 1927 Rolls Royce is still in good working order, and on display in Airfield House. (Courtesy of the Airfield Trust)

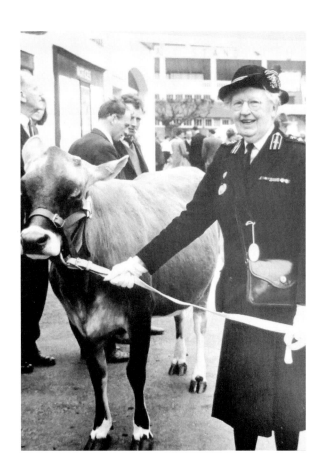

Letitia often entered her Jersey cows in competitions at the Spring Show in the Royal Dublin Society in the 1960s and '70s. (Courtesy of the Airfield Trust)

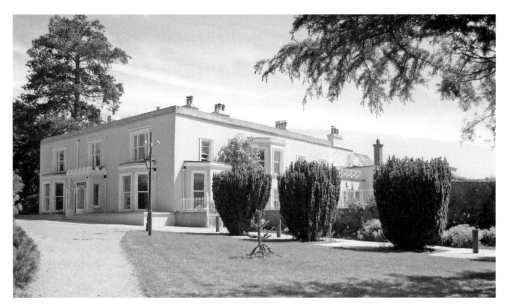

A recent photo of Airfield, Overend Way.

3

RELIGION

HOLY CROSS CATHOLIC CHURCH, MAIN STREET

Back in the eighteenth century, the countryside outside the small city of Dublin was sparsely populated, with only a few places of worship for Catholics. In 1787, Booterstown, Stillorgan, Blackrock and Dundrum broke away from the vast Donnybrook parish and built a parish church in Booterstown. In 1813, a chapel-of-ease was built in Dundrum to serve the small local community, but it did not have a resident priest, and was not dedicated until 1837. On 6 July 1879, because of increasing numbers, Dundrum and Stillorgan became a separate parish. Stillorgan (by then including Kilmacud and Mount Merrion) broke away from Dundrum in 1948 to become a new parish.

In anticipation of its new status as a separate parish, Dundrum residents built a new church in 1878, to a design by George Coppinger Ashlin and built by Michael Meade & Son. By 1956 the church was bulging at the seams, and the sanctuary had to be extended westwards over the site of the redundant National School, using the basement under the altar as a parochial hall.

This granite church sits comfortably amongst the other buildings on Main Street, perhaps because it is devoid of a tower or spire. The interior is not overwhelming, but enlivened by some lovely stained-glass windows, the ornate white marble altar, and the stained scissor-style roof trusses.

To the north of the church is the presbytery, in matching granite, its large size harking back to the middle of the twentieth century, when there were many Masses and many curates.

ST NAHI'S ANGLICAN CHURCH, NEAR DUNDRUM STATION

This tiny rectangular Protestant church was originally the only one in the parish of Taney, and was built in 1760 on the site of a ninth-century Catholic church.

After a larger parish church was built in 1818 on Taney Hill, St Nahi's partially fell into disuse, only used for funerals because of its surrounding graveyard. However, it could now double-up as a boys' National School, which prevented it becoming a ruin. Another cottage at the south-east of the graveyard was used as a girls' National School. School use in St Nahi's was discontinued in 1859 when a new school was erected in Eglington Terrace, behind the courthouse.

In 1910-1914, the church was restored, and became popular as a chapel-of-ease for Taney parish. Stained-glass windows from An Túr Gloine artists such as Alfred Ernest Child, Evie Hone, Catherine O'Brien, and Ethel Rhind, add to the intimate atmosphere.

Four embroidered pictures are displayed (in reality, hidden) under the window on the wall behind the altar, the handiwork of Susan (Lily) Yeats, sister of William Butler Yeats and Jack Butler Yeats. The exquisite New Testament scenes comprise the Woman at the Well, the Prodigal Son, the Lost Sheep, and Disciples Plucking Grain on the Sabbath.

The baptism font in the porch was donated in 1912 after the closure of St Kevin's, Camden Row, and is where the Duke of Wellington was baptised in 1769.

The interesting graveyard is still in use by both Catholics and Protestants – so far the oldest known headstone dates from 1734, but there are probably older ones underneath. Two 'Rathdown slabs' (early Christian gravestones with carved lines) were discovered about ten years ago. In recent decades, a Garden of Remembrance was created to receive the ashes from modern cremations, sadly at the expense of the mass grave which contains the anonymous remains of deceased Christians from the nearby Central Mental Hospital. There are many interesting people buried in St Nahi's, including the Yeats sisters.

CHRIST CHURCH ANGLICAN CHURCH, TANEY HILL

Taney parish is the largest and wealthiest of the Anglican community in Ireland. When St Nahi's became too small for the number of parishioners, a larger building was erected in 1818 on Taney Hill, with a north-south orientation. A major extension fifty years later became necessary as parishioners moved out to the suburbs from the city centre, and galleries on three sides increased the capacity further. The present layout now has the correct east-west orientation. The central flat ceiling, with ornamental centrepiece, helps to lower the eyes towards the marble altar. There are some nice English stained-glass windows, and the usual collection of memorial plaques to deceased parishioners and clergy.

The adjoining Parish Centre dates from 1991 and is a hive of activity all week long, catering for many clubs and activities.

The church tower didn't have a bell until 1999, when a set of old bells was acquired just in time to ring-in the Millennium Year of 2000. St George's church in Hardwicke Street (beside Temple Street Children's Hospital) had a famous set of eight bells, cast in 1828 by Mears of London (later called the Whitechapel Foundry), and ranging in weight from five to twenty hundredweight (cwt). The famous architect, Francis Johnston, who designed St George's, lived nearby in Eccles Street, and because he was an avid bellringer, he commissioned and donated the set of bells to the church. These bells were taken down when that church closed in 1990 and lay in storage for many years until they were donated to Christ Church, Taney. Change-ringers practise mathematical combinations on the bells on Monday

evenings, and again on Sunday mornings, although noise-reducing baffles had to be inserted in the tower louvres so as not to upset the nearby residents.

One of the quaint cottages in the forecourt was once used by the sexton (sacristan), while the other was an infants' school long ago.

The 1860s rectory was demolished about twenty-five years ago, and a small housing estate built on the land, called Old Rectory Park. However, Taney Lawn Tennis Club continued to use four grass courts on part of the old estate until recent years.

METHODIST CHURCH, BALLINTEER ROAD

Lewis records a Methodist church in Dundrum in 1837, although it appears to have been short-lived.

In 1976, Wesley College sold 1.75 acres of its campus to the Dundrum Methodist Society, and they in turn opened a new church in January 1978. For a few years before that, the Methodists had availed of Taney Parish Hall in Eglington Terrace for Sunday services.

QUAKERS, LOWER CHURCHTOWN ROAD

The Friends Meeting House at 82 Lower Churchtown Road was purpose-built in 1861 as a simple hall. Not long after, the hall was extended to the front to provide ancillary accommodation, although the design was different, particularly the use of a hipped roof.

Quakers are Christians, being guided by the Bible. However, there are no priests and no 'Sacraments', and hence no altar. Friends gather in a plain room, and sit in silence in a rough circle, until God inspires one or other to speak about Christian issues.

Quakers have a long tradition in Ireland of being very industrious, and set up many famous companies, such as Bewley's coffee, Pims department stores, Jacobs biscuits, Cadbury's chocolate, Goodbody flour, Malcomsons cotton, etc.

On weekdays, the Quakers use the building for other purposes, such as a children's crèche, thereby making the best use of the Earth's scarce resources.

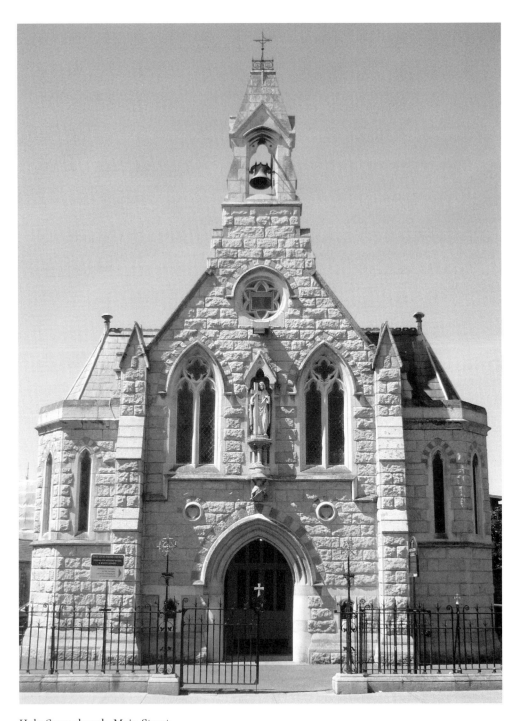

Holy Cross church, Main Street.

Holy Cross church and presbytery as seen from Mulveys yard in 1999.

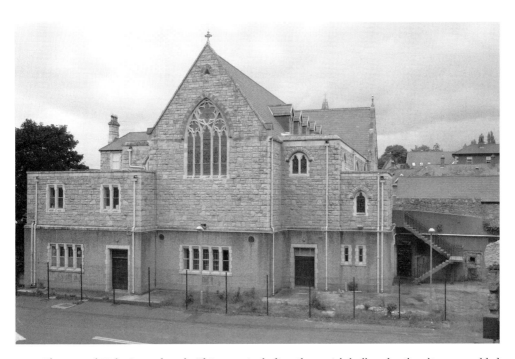

The rear of Holy Cross church. This part, including the parish hall under the altar, was added in 1956, on the site of the 1877 National School.

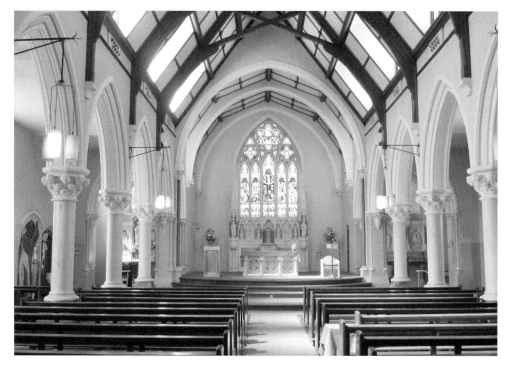

The interior of Holy Cross church in 2001.

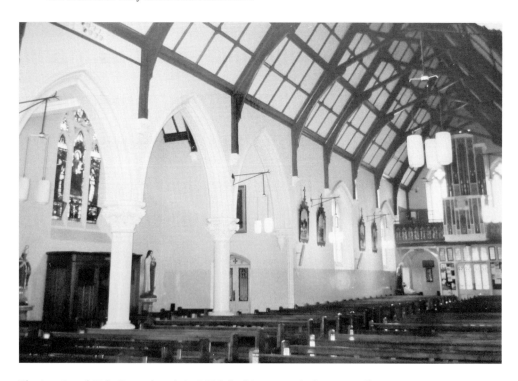

The interior of Holy Cross church in 2001, looking towards the west gallery.

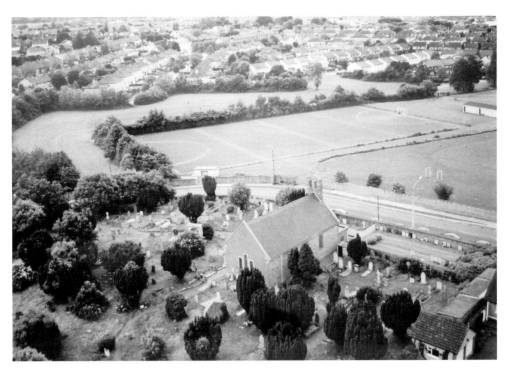

St Nahi's church and graveyard in 2002, with Notre Dame pitches in the background.

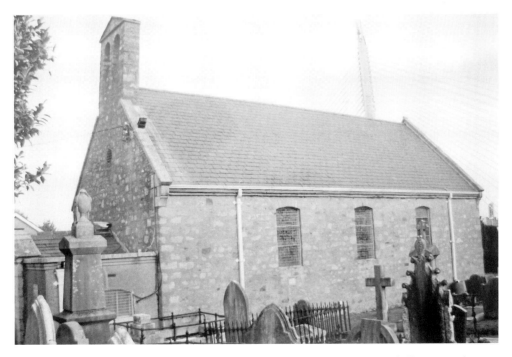

A recent photo of St Nahi's, which is of very simple design. Note the twin-bellcote over the west gable wall. The new Luas bridge is in the background.

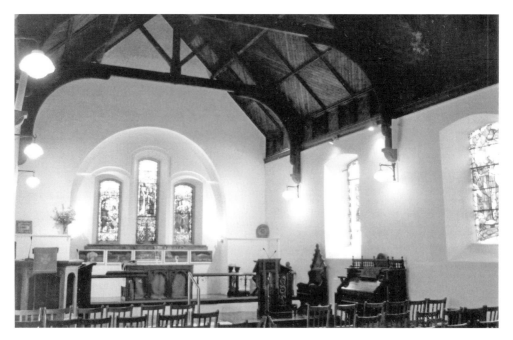

St Nahi's church, with the small embroidered pictures under the Catherine O'Brien stained-glass three-light window, the work of Lily Yeats of Cuala Industries.

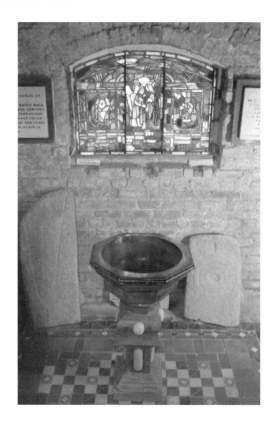

St Nahi's porch/baptistry has an Evie Hone stained-glass window, the baptism font from St Kevin's church and two Rathdown Slabs.

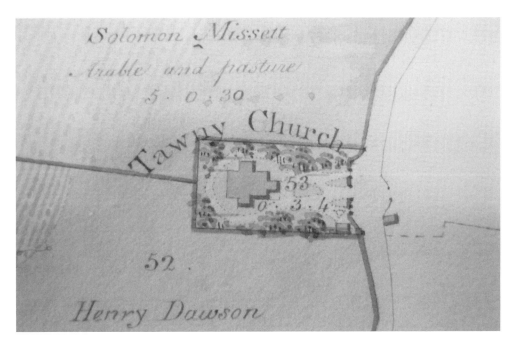

1831 map of Christ Church, Taney, before being extended. There is only one small lodge at this stage. (Courtesy of National Archives of Ireland)

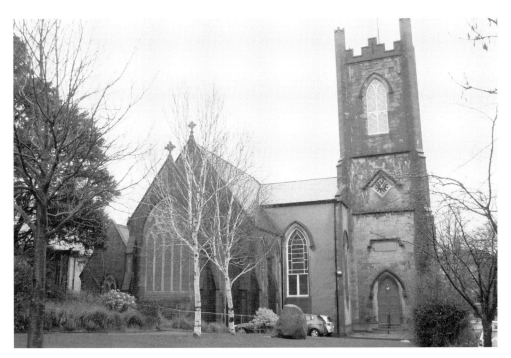

Side-view of Christ Church, Taney, including the granite tower where the old bells of St George's are now housed. The original 1818 nave is rendered and the chancel extension is in limestone.

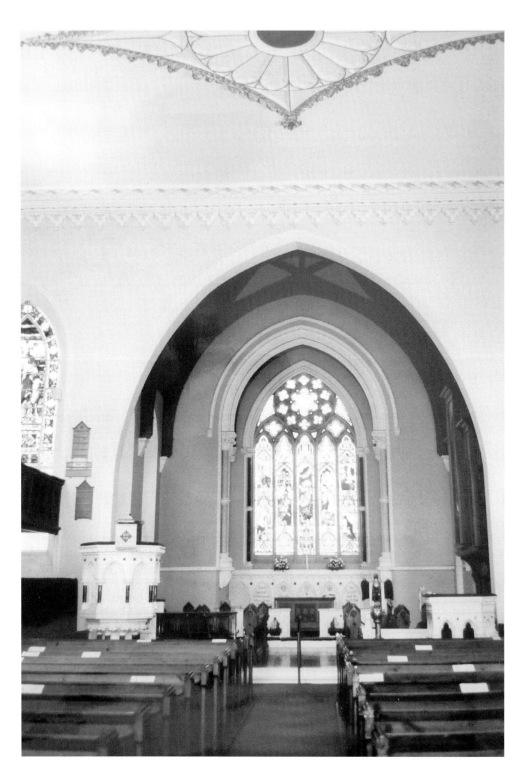

Christ Church, Taney in 2002.

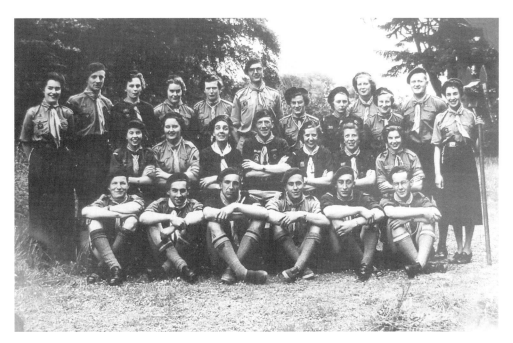

20th South Dublin (Dundrum) Scouts, 1956. (Courtesy of Christ Church, Taney)

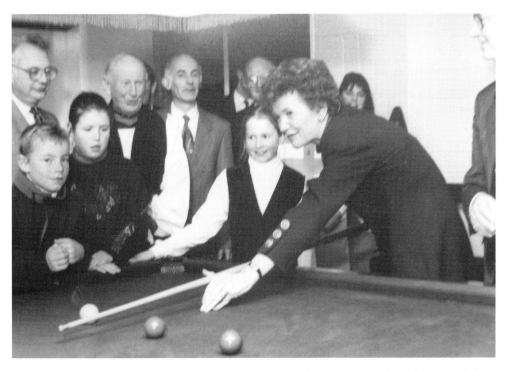

President Mary Robinson opened the new Taney Parish Hall in November 1991. Archbishop Dr Caird is the second adult from left. (Courtesy of Christ Church, Taney)

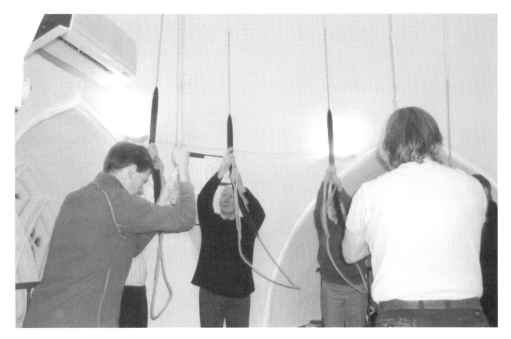

Taney change-ringers in action, 2010. Strength is not necessary to revolve the bells, although you must be of a mathematical (not necessarily musical) disposition.

Ballinteer Methodist church has an industrial design and dates from 1978.

The Methodists in Ballinteer adopt an informal approach at their weekly service.

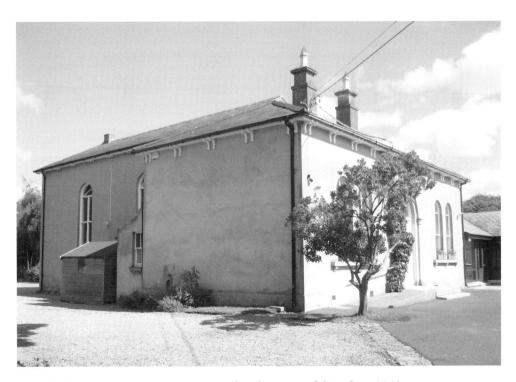

The Quaker Meeting House on Lower Churchtown Road dates from 1861.

2004 view of the interior of Churchtown Quaker Meeting House, where simplicity is at the core of their Christian values.

4

HEALTH

CENTRAL MENTAL HOSPITAL, DUNDRUM ROAD

The Central Mental Hospital on Dundrum Road was built in 1850, at a cost of £19,547, as the Central Lunatic Asylum for Criminals, to a design by Jacob Owen and F.V. Clarendon, to accommodate 120 patients (80 male and 40 female). An extension in 1864 increased the capacity to 130 males and 42 females. Other extensions followed in 1884 and 1887.

Black calp rubble limestone walls with granite dressings and cast-iron windows gives the building an austere look. The patients slept either in individual cells or dormitories. Heating initially was by fireplaces. Toilets ran to an outside tank and the contents then spread as fertiliser on the land. The initial 15 acres was tilled by the patients, such work being regarded as good mental therapy.

Initially there was a Catholic chapel on the first floor in the central administration block. A detached granite chapel was built for the Anglicans at a later stage, probably in the 1880s. In 1893 the Anglican chapel was converted for Catholic use, and the detached two-storey infirmary/hospital was converted for Anglican use. The original first-floor chapel is now the Music Room, used for concerts and plays.

There was a mortuary just to the south of the gate lodge. The patients were buried anonymously in St Nahi's graveyard, where a tall and slim stone cross stood just inside the gate to the left. Recently, this plot has been used for private cremation urns.

A Government Report for the year 1853/54 recorded 119 patients (77 men and 42 women), supervised by 7 officers and 20 attendants. The male patients spent their days in farming and gardening (24), tailoring (2), shoemaking (4), carpentry (2), cleaning the house (6), miscellaneous (21), or were inactive (16) or in bed (2). The female patients did needlework (7), knitting (7), laundry (10), cleaning house (5), miscellaneous (2), or were inactive (11). The excess farm produce was sold to the public, resulting in a net profit of £126.

In the 1890s the attendants sometimes worked with the patients on the farm, and by then, gratuities were given to the patients for their labour efforts. By this stage, the asylum had a cricket team.

The Census of 1901 and 1911 records the various illnesses of the patients in the hospital, including quite a few suffering from 'dementia'. In 1911 there were 169 patients in the hospital.

Non-criminal lunatics were held in many mental asylums around the country, and the famine workhouses also had accommodation for lunatics. Even some gaols had a few lunatics.

Nowadays the 34-acre site is a peaceful oasis, with many mature and exotic trees, and plenty of colourful flowerbeds.

ELM LAWN PRIVATE MENTAL ASYLUM, SANDYFORD ROAD

This was a private female facility for women, located immediately to the south of the present Eagle House public house, with frontage to the Sandyford Road and the Kilmacud Road, on a site of more than one third of an acre (1 rood and 20 perches). It could cater for ten patients, but usually had fewer. A Government Report for 1912 records that the house and grounds were in good condition. It seems to have operated from about 1884 to 1925, and was owned by Miss Sarah Bernard (Church of Ireland), who was born around 1850. Michael Bernard (her father) was listed as the doctor in the Dundrum Dispensary for a few decades, living in Elm Lawn.

According to the Census of 1911, the house had nine front windows and had nineteen rooms.

Around 1925 the sprawling house was split into three houses. These days the original front part is combined with neighbouring Lynton into a fitness club. The last house in the terrace, Ashgrove, was demolished in recent decades, and blocks of apartments built in the large side garden.

SIMPSONS HOSPITAL, BALLINTEER ROAD

This small hospital/nursing home for men and women, funded by the Health Services Executive, was founded under a bequest of George Simpson, merchant, in 206 Great Britain Street (now Parnell Street). Archer, in his *Statistical Survey of Ireland*, 1801, says that it was incorporated by Act of Parliament in March 1780, and opened in 1781 for 'poor, decayed, blind, and gouty men', accommodating seventy-two men in that year.

The hospital moved to Wyckham House in Dundrum in 1925 with Miss Berney as matron. The house was called Primrose Hill in the latter half of the eighteenth century. In 1865 Sir Robert Kane was in occupation – he was Director of the Museum of Irish Industry at 51 St Stephens Green, run by the Board of Trade.

The original city centre building became Williams and Woods sweet factory in 1876, but was demolished in 1978, and is now the site of a multiplex cinema.

DISPENSARY

The Dispensary was the forerunner of the Local Health Centre, where the general public could see a doctor for free, and receive their free medicine in the same building. Vaccination of children against infectious diseases was an important element of the doctor's work.

Dundrum Dispensary is marked on the 1837 Ordnance Survey map, just north of the present-day Bank of Ireland. In 1930 it was located at 2 Pembroke Terrace, beside the then Telephone Exchange in No 3. In recent years, the flat-roofed building behind the library was the Local Health Centre.

Isaac Usher was the popular dispensary doctor from around 1875. He lived in 1 Eglington Terrace initially, then Tudor House on Taney Road for many years, and from around 1900 lived in Laurel Lodge (opposite the rear of the Holy Cross church – now a large block of apartments). When he died following a car accident in 1917, local people erected a stone obelisk/water fountain beside the railway station in his honour. The adjacent office block dates from around 1970, and is called Usher House – it was raised in height and re-clad during the recent Celtic Tiger years.

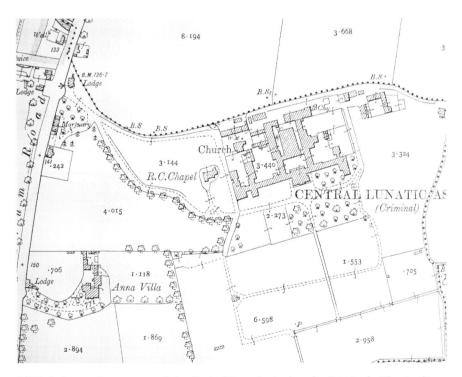

1908 Ordnance Survey map of the Central Lunatic Asylum for Criminals. The Anglican church is now in the former infirmary, and the Roman Catholic chapel is now in the original Anglican building. (Courtesy of Trinity College Map Library)

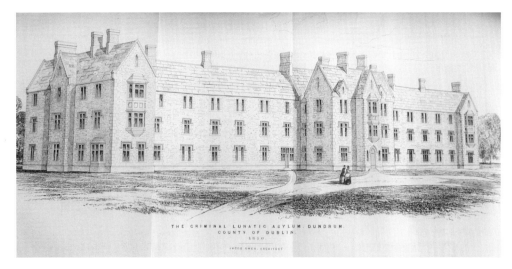

1850 as-built depiction of the Central Lunatic Asylum. (Courtesy of Irish Architectural Archive)

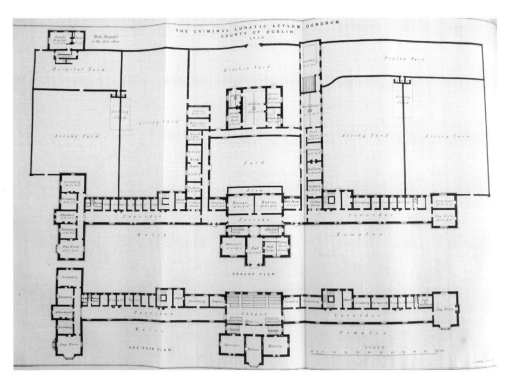

1850 as-built floor plans of the Central Lunatic Asylum. The ground floor layout is at the top, and the layout for both upper floors is at the base. The chapel is in the centre of both the first and second floors. The hospital/infirmary is at the top left. (Courtesy of Irish Architectural Archive)

TABLE XV.—DETAILED STATEMENT of SALARIES and WAGES, showing the Rates of Pay and Allowances, for the Year ended 31st March, 1893.

No. actually employed.	Description of Office.	Salary of Office.			Allowances.	Valued at
		Minimum.	Annual Increase.	Maximum.		
		£ s. d.	£ s. d.	£ s. d.		£ s. d.
1	Resident Physician and Governor,	600 0 0	20 0 0	700 0 0	House and garden,	100 0 0
1	Assistant Physician,	—	—	200 0 0	Furnished apartments, fuel, and light,	60 0 0
1	Visiting Physician,	—	—	175 0 0	None.	—
1	Clerk and Storekeeper,	150 0 0	10 0 0	200 0 0	For house,	30 0 0
1	Assistant Clerk and Storekeeper,	80 0 0	5 0 0	100 0 0	For house,	15 0 0
1	Protestant Chaplain,	—	—	50 0 0	None.	—
1	Presbyterian Chaplain,	—	—	25 0 0	None.	—
1	Roman Catholic Chaplain,	—	—	80 0 0	None.	—
1	Male Head Attendant,	80 0 0	2 10 0	110 0 0	House and uniform,	21 10 0
4	Charge Attendants,	52 0 0	1 0 0	58 0 0	⎫	
12	Attendants,	42 0 0	1 0 0	50 0 0	⎬ Quarters, rations, fuel, light, and uniform,	40 0 0
10	Assistant Attendants,	30 0 0	1 0 0	40 0 0	⎭	
1	Female Head Attendant,	40 0 0	2 0 0	52 0 0	Rations, uniform, and quarters,	37 0 0
3	Charge Attendants,	20 0 0	1 0 0	36 0 0	⎫ Quarters, rations, and uniform,	35 0 0
8	Attendants,	18 0 0	1 0 0	28 0 0	⎭	
1	Farm Yardman,		2s. 6d. per day.		None.	
1	Boy Messenger,		1s. per day.		None.	

1893 Government Report, listing the number of staff and their salaries at the Central Lunatic Asylum. (Courtesy of Central Mental Hospital)

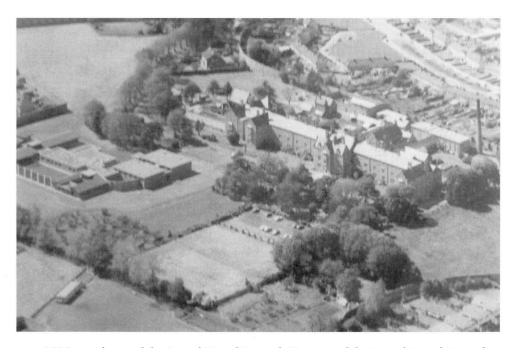

1970s aerial view of the Central Mental Hospital. (Courtesy of the Central Mental Hospital)

Part of the front of the Central Mental Hospital today.

Recent photo of the entrance block of the Central Mental Hospital, with its famous red door.

The first-floor corridor in the Central Mental Hospital today.

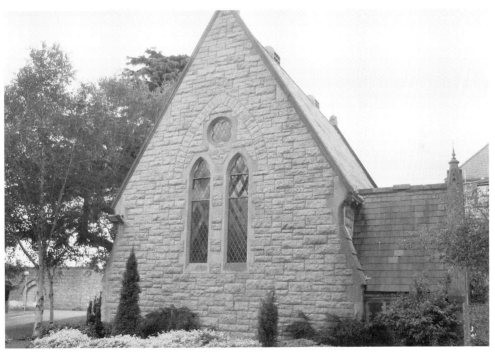

The former Anglican church in the Central Mental Hospital became the Catholic chapel around 1893.

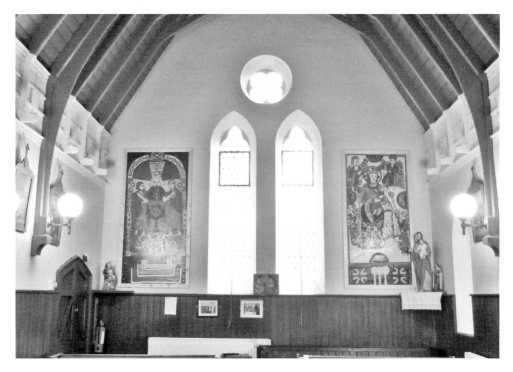

The excellent paintings on the west gable wall of the chapel in the Central Mental Hospital are the work of some previous inmates.

TABLE XIII.—Showing the probable Causes of Insanity in the Patients who were admitted during the Year 1892.

CAUSES.	Males.	Females.	TOTAL.
MORAL CAUSES:—			
Domestic trouble,	71	86	157
Adverse circumstances,	50	24	74
Mental anxiety and worry,	63	61	124
Religious excitement,	32	27	59
Love affairs,	7	20	27
Fright and nervous shock,	16	40	56
PHYSICAL CAUSES:—			
Intemperance in drink,	208	82	290
,, sexual,	2	1	3
Venereal disease,	11	2	13
Self abuse (sexual),	24	2	26
Over-exertion,	1	2	3
Sunstroke,	21	2	23
Accident or injury,	35	9	44
Pregnancy,	—	14	14
Parturition and the puerperal state,	—	39	39
Lactation,	—	10	10
Uterine and ovarian disorders,	—	36	36
Puberty,	7	4	11
Change of life,	—	8	8
Fevers,	4	10	14
Privation and starvation	12	13	25
Old age,	32	31	63
Other bodily diseases or disorders,	100	75	175
Previous attacks,	122	143	265
Hereditary influences,	370	293	663
Congenital defect,	51	16	67
Other ascertained causes,	23	10	33
UNKNOWN,	468	388	856
NOT INSANE, OR INSANITY DOUBTFUL,	3	—	3
Total,	1,733	1,448	3,181

This 1893 Government Report lists the causes of insanity in new patients admitted to the Central Lunatic Asylum in 1892. (Courtesy of the Central Mental Hospital)

855.—E. W., male, admitted from Mountjoy Prison where he was undergoing seven years' penal servitude for robbery with violence. Subject of chronic mania with periodic exacerbations. A dangerous character and a determined runaway.

856.—T. H., male, admitted from Waterford Prison; crime, indecent assault. A congenital imbecile, with uncontrollable temper.

857.—A. S., male. See 851, readmitted from Belfast Prison, after being tried for murder. A case of simple melancholia, steadily progressing to recovery.

858.—M. M., male, admitted from Mountjoy Prison ; crime, murder. Sentenced to death, commuted to penal servitude for life. A dangerous character and a determined runaway.

859.—H. C., male, admitted from Mountjoy Prison, where he was undergoing a sentence of five years' penal servitude. A dangerous character, marked criminal type.

860.—J. K., male, admitted from Wicklow Prison ; crime, murder. A deaf mute, and congenital imbecile.

861.—S. M'C., female, admitted from Belfast Prison ; crime, murder. A very interesting case, extremely acute, rapidly passing from mania into melancholia, with lucid intervals followed by severe relapses. Resembles what is known as *Folie Circulaire.* Her health has improved very rapidly, but the mental recovery has not kept pace.

862.—J. B., male, admitted from Mountjoy Prison ; crime, grievous assault. A case of simple melancholia, has made a rapid recovery mentally, and the improvement in bodily health has been phenomenal.

863.—W. R., male, admitted from Cork Prison ; crime, arson. A case of senile melancholia, and in an emaciated condition. He is gaining flesh, and now works on the farm, but lives in perpetual fear of being injured, and being " destroyed in his mind " by the attendants.

864. M. K., male, admitted from Cork prison ; crime, malicious injury. A case of complete break down, mental and bodily, at age of sixty-seven. He exhibits a want of recuperative power, and is, I fear, a hopeless case.

GEORGE REVINGTON, M.D.

Resident Physician and Governor.

This section of an 1893 Government Report lists the background of a selection of inmates in the Central Lunatic Asylum. (Courtesy of the Central Mental Hospital)

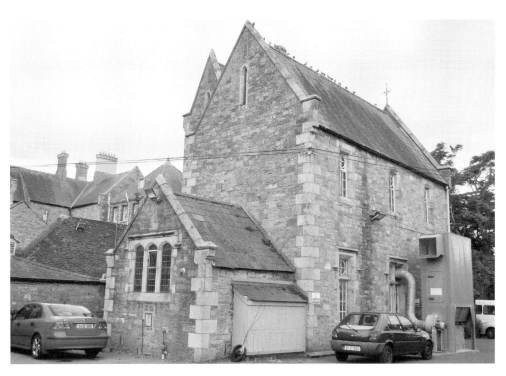

The former infirmary/hospital in the Central Lunatic Asylum became the Anglican church.

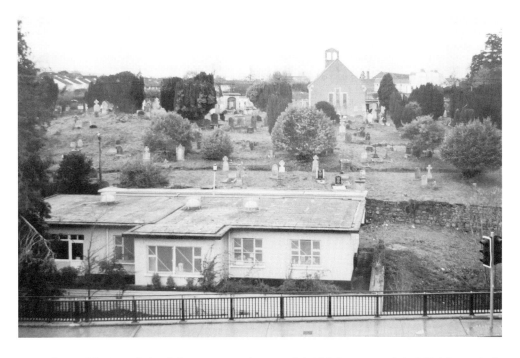

The Health Centre behind the Carnegie Library and St Nahi's graveyard, in 2004. It was built by W. & J. Bolger in 1947.

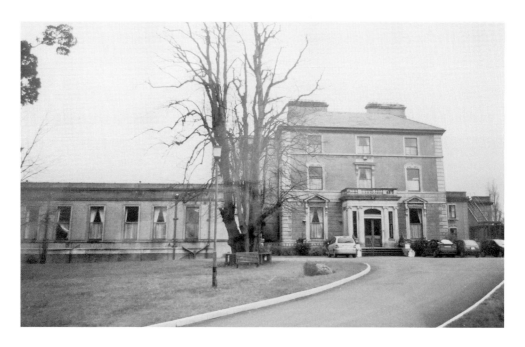

Three-bay Simpsons Hospital in 2003. The house was previously called Wyckham (Wickham).

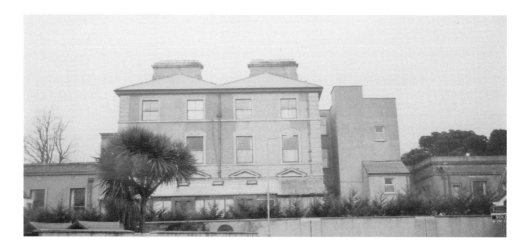

The rear of Simpsons Hospital in 2003.

5

BUSINESS

DUNDRUM TOWN CENTRE

The northern part of this modern shopping centre occupies the site of an eighteenth-century mill, then an ironworks, which became the Manor Mill Laundry, and then the Pye Centre.

The Pembroke Estate map of 1754 shows a mill on the River Slang, with the mill-wheel positioned on/in the river itself.

Archers Survey of 1801 records 'three mill-wheels, iron works, owned by Mr Stokes' in Dundrum, and it also records a paper mill elsewhere in Dundrum, owned by Mrs Hall. Dundrum Ironworks and a mill pond are recorded by Lewis in 1837, and shown on the Ordnance Survey map. A Pembroke Estate valuation in 1831 records a William Mallet occupying an iron mill, on 1 acre. George Sikes is recorded as the owner of Dundrum Ironworks in 1845. The River Slang, a tributary of the River Dodder, fed the mill pond, which provided the water power to drive the waterwheel, which in turn drove the various machines. In later years, the waterwheel may have been replaced by a cast-iron water turbine. This little river can still be seen today, alongside the Dundrum by-pass, at the side of the library, and in various locations down towards Frankfort Park, Farrenboley, etc, whereas the southern portion is culverted through the underground car parks of the Dundrum Town Centre.

Hewetson Edmondson, a member of the Plymouth Brethren, came over from England to try his hand in the laundry business, and started the Manor Mill Laundry in 1863, demolishing the redundant ironworks and erecting a new larger premises. This was the first steam-powered laundry in Ireland – a boiler produced steam, which powered an engine, in turn connected to belts to drive the various washing and drying machines. Hewetson died in 1867, aged 41, and his wife, Huldah, carried on the business, employing his brother Thomas Edmondson as manager. Because of a dispute over the partnership, Thomas left in 1887 and opened the Dublin Laundry in nearby Milltown in 1888, taking some of the key workers with him. The Dublin Laundry eventually became one of the biggest in Dublin, and lasted until the early

1980s – Shanagarry apartments were later built on the site, but the redbrick chimney stack from the laundry survived the bulldozer.

The Manor Mill Laundry carried on under Huldah Edmondson, and in due course her two sons, Joseph (born 1859) and George (born 1864) were at the helm.

Substantial building works were carried out in 1884/85, at a cost of £2,350, by Collen Bros contractors, under architect J.F. Fuller.

A local newspaper wrote a feature article about the laundry in 1896, stating that around 100 locals worked in the recently rebuilt premises, which had spacious bleaching grounds around it. The manager's house (the present Roly Saul restaurant) had a large flower garden adjoining the large open drying grounds, where sheets and blankets were hung out to dry. The Sorting Department received the customer's baskets of soiled clothes, accompanied by a Washing List Book, and each item was marked, to enable identification before dispatch from the Packing Department. The Wash Room was 70ft by 25ft, containing washing, rinsing, bluing, and boiling machines. The clothes were initially dried by centrifugal wringers, operating at 1,000 revolutions per minute. The Drying Department had two chambers, with hot air passing alternately through each, heated by underground fires. The Ironing Department was twice the size of the Wash Room, operating gas irons, and contained a special machine for putting a gloss on shirt fronts, a roller collar machine handling 4,800 dozen collars a day, curling machines for finishing off shirt collars and cuffs, and large revolving machines for sheets, pillow cases, table linen and napkins. From the roofs were suspended hundreds of newly ironed print-dresses and blouses. The finished work was taken in baskets by lift up to the Packing Department. The horse-drawn vans waited under cover, outside the Packing Department, and then delivered the baskets of clean clothes to all parts of Dublin, including Howth and Greystones. Other parts of the laundry included the stables (for twelve horses), harness room, fitters' and carpenters' shops, two powerful boilers for generating steam, a steam engine, and a turbine, the latter two used for driving the machines. The turbine would have been a modern replacement for a conventional waterwheel, powered by the water from the mill pond and River Slang. The article concluded by referring to the city office/shop at 13 Castle Market (South Great Georges Street), and the agency for the Perth Dye Works (the competing Dublin Laundry in Milltown had a sister company called the Dartry Dye Works, started in 1895).

The Manor Mill Laundry ceased operations in Dundrum in 1942, and the business was transferred to the Imco Works in Merrion (roughly opposite the Sisters of Charity Home for Blind People). The business was then run by Louis and Harold Spiro, employing 360 workers in the 1940s. The Brown Thomas Group acquired the company in 1966, closing the Merrion laundry and instead operating from a chain of working shops, concentrating on 'dry cleaning'. Prescotts took over the chain in 1968.

In 1877, during the early tenure of the Manor Mill Laundry, the Landed Estates Court sold the landlord's interests in the property, comprising a large plot of land between the Sandyford Road and Ballinteer Road. The title comprised a lease of nearly 42 acres for 99 years from 1786, between Lord Fitzwilliam and Randall McDonnell, and there was an old castle, a house, and several cabins on the land, formerly occupied by Anthony Dawson, and then by Randall McDonnell. There was a covenant to build a house within five years for at least £2,000. In 1817 McDonnell let about half of the land to John Walsh, comprising an old castle, a dwelling house, a small dwelling at the north-east corner beside the Powerscourt Road occupied by Thomas Missett, a cabin

on the Powerscourt Road occupied by Edward Casey, the Iron Mills of Dundrum with wheels, machinery, tools and two dwelling houses adjoining the mills, and garden at the rear of, subject to the lease of the mill and one of the houses and a garden to J. and E. Norris for thirty-one years from 24 December 1795, and subject to the right of the public to draw water from the well at the north-east boundary of the land. The 1817 lease makes no reference to a mill pond, so presumably it was built before the 1837 Ordnance Survey.

Pye (Ireland) Ltd started business in 1937 at 10 Temple Lane, in the city centre, initially distributing 'Hercules' bicycles, and then manufacturing radio sets. They moved to the old Manor Mill Laundry premises in Dundrum in 1943, and started making television sets in 1953. Such was their expertise in electronics that in 1961 they won the contract to provide transmitters on the new Telefís Éireann mast on Kippure Mountain in Wicklow – Ireland's first television station.

By this stage the old laundry premises had been extended to around 90,000ft^2, and 520 workers were employed, including 372 women. But more space was needed to satisfy the demand for television sets, and a new 52,000ft^2 factory was built some distance to the south of the main works. However, business did not expand, and the new building was sold to H. William supermarket in 1968 for £212,500 – in later years Super Crazy Prices was the occupier. Meanwhile, Pye diversified into the manufacture of fridges.

The 1937 directors were Charles Stanley (chairman), James Digby (managing director), Hodson, Bradshaw, and the secretary was Olden. In the 1960s and 1970s Charles Stanley was still chairman (including the Cambridge parent group), and L. Dillon Digby was MD, alongside Commander Alan R. Bradshaw. The Digby family lived for many years in Mill House fronting on to the Sandyford Road, which seems to date from around 1800, although the two-storey rear extension dates from the 1890s.

Pye closed in 1985. The north part of the factory was immediately converted into Dundrum Bowl by Jim McKernan, and opened in December 1985 with fourteen tenpin bowling lanes. The basement under the bowling alley was the first in Ireland to introduce the Quasar military game in 1989. Following a serious flood in 1993, Dundrum Bowl closed. A variety of other small businesses occupied the remainder of the Pye Centre over the years, including Typecraft printers and Royale Fireplaces.

In the opening years of the new millennium, Chartered Land redeveloped the 21 acres of the old Pye Centre into Ireland's largest shopping centre, which included the excavation of a huge basement car park by blasting out vast quantities of granite. Their architects, Burke Kennedy Doyle, created an external design which fits very well into the south end of Dundrum village. The 1.34 million ft^2 Dundrum Town Centre opened in 2005, and comprises: offices, 3,400 underground car spaces, a petrol station, 50 restaurants and 120 shops, anchored by such names as House of Fraser, Marks & Spencer, Penneys, Tesco, Harvey Nichols, H & M, etc. The old mill pond is now an active feature of the public plaza at the north end, adjacent to a theatre, cinemas, pubs, and restaurants. The old Manor Mill House is now occupied by Roly Saul Restaurant.

Opposite the south wall of Roly Saul is a lovely stone monument in the shape of a wheel, in recognition of Dundrum cyclist Stephen Roche, who won the Tour de France in 1987. As a further tribute to this super athlete, the organisers of the Tour arranged for it to actually start in Main Street, Dundrum in 1998.

Sadly, there is no monument to the rich history of the site of the Dundrum Town Centre, encompassing mills, laundry, radio and television factory, and their hundreds of loyal workers.

DUN EMER GUILD AND CUALA INDUSTRIES, SANDYFORD ROAD

The Dun Emer Guild was started in 1902 by Evelyn Gleeson, Susan (Lily) Yeats and Elizabeth (Lolly) Yeats, based in an old house called Runnymede on the Sandyford Road, at which stage the ladies changed the name to Dun Emer House (now demolished). Lolly specialised in high-quality hand printing, Lily looked after embroidery, while Evelyn was in charge of tapestries and rugs, with the emphasis on Irish works, employing young girls. Around 1907/08, the Yeats sisters parted company with Evelyn, and they set up Cuala Industries in their home 'Gurteen Dhas' on the Upper Churchtown Road, the central house of a small terrace of two-storey houses opposite the side of the present Bottle Tower public house. The business later moved into the city, lasting until the 1940s.

Lily and Lolly Yeats were sisters of the famous poet, William Butler Yeats, and artist, Jack Butler Yeats. The sisters worshipped in nearby St Nahi's church and are buried in the adjoining graveyard.

CENTRAL BANK, SANDYFORD ROAD

The Central Bank Currency Centre, where banknotes and coins are manufactured, opened in Sandyford in 1978. Prior to this, banknotes were made by De La Rue printers in Clonskeagh, and most of their workers moved to Sandyford.

The bank acquired an old house called 'Moreen', on 100 acres, where a previous owner had a private horseracing track. Architect Sam Stephenson won the RIAI Gold Medal for his design, comprising a cluster of low-rise buildings, using brown brick, large steel windows with rounded corners, and flat roofs. Not visible to the public are the charming landscaped courtyards, with ponds and sculptures. The twin granite sculptures in the courtyard beside the reception is the work of James McKenna, entitled 'Female Figure and Tree', carved in 1979 – the plaque at the base of the sculpture mistakenly labels the ensemble 'Tree of Life'.

Another south-east block was added in the 1980s, just to the south of the original old house. In the 1990s, the estate was reduced in size when the new M50 motorway cut off a large slice of land.

The bulk of an old ruined chapel in the grounds is now gone – the site is beside J14 on the M50, marked by three old chestnut trees. Ball, writing in 1903, says that, according to folklore, the chapel was built when two feuding families settled their differences and built the tiny church to commemorate the occasion. It was known as the Cross Church of Moreen. Archaeological excavations for the M50 in 1990 found the stone foundations for that church, 7.2ft by 23.6ft externally. Early medieval remains were also found around the church, including a partial 'strap-tag' (a type of buckle for a leather shoulder strap), and some pottery.

Directly across the M50 in Kilcross Estate, there is the remnant of a Pale Ditch, and also FitzSimons Wood, where Countess Markievitz trained Fianna Éireann before the 1916 Easter Rising.

ORIGINAL DUNDRUM SHOPPING CENTRE, MAIN STREET

The Stillorgan Shopping Centre was the first in Ireland, opening in 1966. Developer Charlie Kenny opened Dundrum Shopping Centre in 1971, on the 4.2-acre site of an old house called Glenville. The 90,000ft^2 centre was anchored by Quinnsworth supermarket, and the range of shops comprised Pick a Shoe, Roberts Furniture, Berney Mastervision TV, Molloy fish & poultry, Wilson meat & poultry, O'Sheas florist, Accurate jewellers, Candid Camera print & develop, Brennans Sports Centre, Mamies, Thomas Farmer chemist, O'Meara Camping, D & N Shoes, Bewleys Oriental Café, Premier Manshop, Merren butchers, Blue Line Cleaners, Kerry Arne children's wear, Penneys, Martin's Travel, Ulster Bank, Haircare by Herman, Carroll optician, Fabric Boutique, Trend Décor, Sound Centre records, Educational Building Society, The Last Word Gift Boutique, with Nicholas O'Dwyer, consultant engineers, in the offices above the bank.

During the Celtic Tiger years from 1995 to 2007, the developer of the new Dundrum Town Centre had plans to extend the centre on to the site of the 1971 shopping centre, but alas, the bust hit hard. Now German retailer, Lidl supermarket, is the anchor tenant, supported by a new range of smaller shops.

MULVEYS BUILDERS PROVIDERS, MAIN STREET

Mulveys Builders Providers was originally started by Mary Cahill from Tipperary in 1913 as a drapery shop in Rathmines. After she married, the Mulveys moved to Dundrum on 8 December 1928, taking over the Saunders premises, which was a hardware and drapery store. 'Riversdale' was the residence attached to the business, with the back garden sloping down to the River Slang. The business expanded into hardware in the 1960s, and then became a fully-fledged builders providers and DIY store in the 1970s, at which stage the south part of the shop was demolished to provide a good vehicular route down to the main storage sheds.

The Mulveys were related to the P.V. Doyle family, which had built a lot of houses around Frankfort Park in Dundrum.

Mrs Mulvey became a county councillor, and Mulvey Park housing estate was named in her honour.

At its height, the business employed forty-two staff, and when it closed in 2001, it left a big void in the bustling life of the village.

BANKS

The Hibernian Bank was based in Mahers Terrace, and then taken over by Bank of Ireland in 1958 – the latter built a new premises near the Usher monument in 1981.

The Munster & Leinster were based in Claremount Terrace beside the VEC, and became part of the new Allied Irish Banks (AIB) in 1966.

Permanent TSB was previously the Trustee Savings Bank. In the 1970s the building was occupied by the Green Shield Stamp Company and in the 1960s by Powers supermarket. Green Shield stamps (light green in colour, with a little

shield in the centre) were collected by shoppers, pasted into a little book, and then redeemed for small household goods, beautifully displayed in the showrooms. There was another larger showroom in Mary Street in the city centre. Nowadays, shoppers collect 'points' and obtain discounts on their shopping bills.

The Credit Union now competes with the banks, operating from a large modern premises, and started in a small house on the same site called Pembroke Lodge, the home of a local builder called Richardson.

The Post Office has been an integral part of life in Dundrum for the best part of 200 years, but never occupies the same building for long. The Post Office is marked on the first Ordnance Survey map of 1837 a short distance to the south of the present Bank of Ireland.

SHOPS

Campbell's Shoe Repairs are still trading from Mahers Terrace, having started here around 100 years ago (although the terrace dates from the mid-nineteenth century). New 'soles and heels' have become fashionable again in the recent recession.

Findlater's grocery shops were an institution throughout Dublin city and county, with branches in all important locations, many sporting external triangular-shaped clocks. Alex Findlater, a Presbyterian, started in O'Connell Street in 1845, and the group only declined in the 1970s. The Abbey church in Parnell Square was paid for by the Findlater's, and hence was also known as Findlater's church. The Dundrum branch was quite a small one, and was located at 14 Main Street from 1945 to 1969.

Joe Daly Cycles was known throughout Dublin, especially amongst cycling clubs. His surname was Tansey, but as he was reared by his aunt, he adopted her surname, Daly. Joe worked for seventeen years in Mellons Garage on the Sandyford Road, driving the taxi, selling petrol at the kerbside pump, and working as a mechanic. In October 1951 he started a bicycle shop just north of the railway bridge. The recent construction of the Luas bridge necessitated a temporary move to the Main Street, and then his sons built a new oblong-shaped building beside the new bridge in 2007, with the shop on the ground and basement floors, and commercial offices on the two upper floors.

Leverett and Frye were high-class grocers at the corner of Main Street and Kilmacud Road for most of the first half of the twentieth century. Their other branches included Grafton Street, Amiens Street, Sandymount, Drumcondra, Rathgar, and Bray. The plaque on the gable wall indicates that the building dates from 1881, and was built by local builder William Richardson. Nowadays, Ladbrokes Turf Accountants trade from the building.

PUBLIC HOUSES

Dundrum House was called J.C. Kerins in 1940, featuring a cocktail lounge and ladies room, and boasting of the city bus stop at its door. At that time the owner also had a pub at 75 Dame Street, and lots of pubs in England. In the 1950s, the Murphy family were operating the pub, calling it the Dundrum Hotel, and later the Clarke family were in charge. The Clarkes are also associated with the Eagle House pub on the opposite corner to Ladbrokes bookies.

Deveneys Off-Licence has been trading opposite the Eagle House pub for many decades, although the gable wall plaque indicates that the building dates from 1886.

Uncle Tom's Cabin was built around 1860, and run successively by Thompson, Patrick Finney, John Murphy, and then James Collins and his descendants from the early 1890s up to the present day. In its heyday, it was also known as the Dundrum Tea Garden and Cyclists Rendezvous.

MISCELLANEOUS

Before the advent of electricity, Dundrum had its own gas supply, manufactured on the site behind the present Bank of Ireland.

Just south of the present Deveneys Off-Licence on the Sandyford Road, Mellons Garage operated from the early twentieth century until about 1970, offering a taxi service in the early days, and petrol pumps as more people bought cars. Horses were still important during most of this period, and the village had a few blacksmiths, including one beside the library – not forgetting the ironworks on the old Laundry/Pye site.

Dublin Crystal is a new arrival, but this firm is nearly fifty years in business, having started in Carysfort Avenue in Blackrock, and moved to Dundrum in 2001 (behind the petrol station just north of the Luas bridge).

RAILWAY AND TRAM

The railway transformed Dundrum from a rural backwater into a thriving small town. The world's first commuter railway was built in 1834 by the famous contractor William Dargan, linking Westland Row in Dublin city with Kingstown (now called Dún Laoghaire). Twenty years later in 1854, Dargan built the railway line from Harcourt Street to Bray, including a fancy station building at Dundrum, near his own home, Mount Anville (now a famous girls' school). On the opposite platform in Dundrum, accessed via a metal bridge across the line, there was a signal cabin, a supplementary booking office, and another waiting room. In due course, Coras Iompair Éireann (CIÉ) took over the line, but closed it in 1959. The short steel bridge over the main road was demolished a few years later.

The LUAS light rail system was introduced in 2004, utilising the route of the original railway. A trendy 'cable-stayed' bridge was built over Taney Road junction, supported from a gigantic concrete pylon, and named the William Dargan bridge, but Dargan himself might have preferred the modern equivalent of arches (echoing his Nine Arches limestone bridge at Milltown), or something elegant in steel, such as the Luas bridge over the Leopardstown Road/Brewery Road roundabout.

APOLLO CINEMA

Just a few doors to the north of Joe Daly Cycles is the Apollo Building, which started life as the Odeon Cinema in 1942, with a capacity of 600 (and 500 bicycles!). Henry J. Lyons was the architect, and R.G. Kirkham of Ballsbridge was the builder.

It closed in 1959, but re-opened as the Apollo Cinema in 1961, lasting until 1967, as more and more people acquired television sets. Some people may remember the Variety Shows which accompanied the films, making an evening out very enjoyable.

ASTOR BALLROOM/DANCE HALL

Diagonally across from the Apollo Cinema was the short-lived Astor Ballroom, run by boxer Eddie Downey in the late 1950s, and frequented by various showbands of that era.

It later became the Ulster Bank, and then the Astor Billiard Saloon. The main building is now Dundrum Stationery (started in 1973) and White Star cleaners, while the single-storey foyer is now the St Vincent de Paul charity second-hand shop. The tiny raised stage is now the cash-register area in the stationery shop.

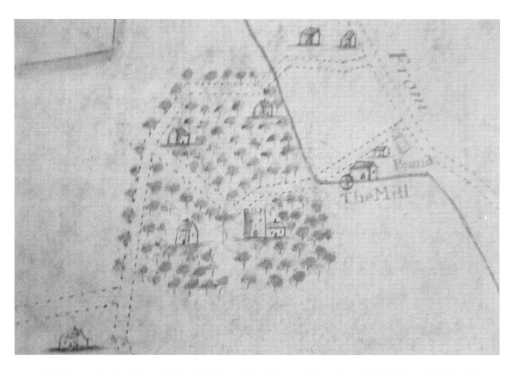

1754 map by Jonathan Barker for Fitzwilliam Estate. Note the millwheel on the River Slang. The 'Pound' was for collecting stray cattle on the roads around Dundrum. Dundrum Castle is to the left of the mill. (Courtesy of National Archives of Ireland)

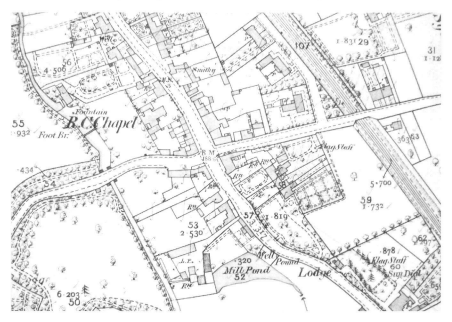

1866 Ordnance Survey map. Dundrum Ironworks, to the left of the mill pond, had recently become the Manor Mill Laundry. Note the National Schools attached to the transepts of Holy Cross church. (Courtesy of Trinity College Map Library)

SOUTH DUBLIN INDUSTRIES.

MANOR MILL LAUNDRY, DUNDRUM.

The Manor Mill Laundry was rebuilt in the 1880s. (Courtesy of National Library – *Rathmines News and Lantern*, 1896)

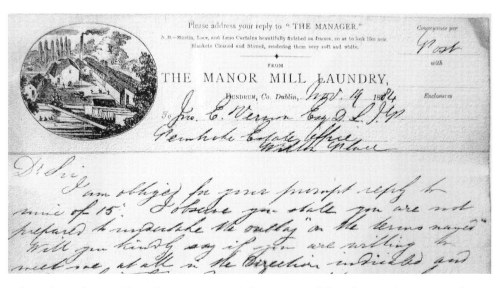

A letter from Thomas Edmondson, manager of the Manor Mill laundry, to John Vernon of the Pembroke Estate office in Wilton Place (beside Baggot Street bridge), concerning drainage problems, 1884. Thomas Edmondson founded the famous Dublin Laundry in Milltown four years later. (Courtesy of Kathleen Kinch)

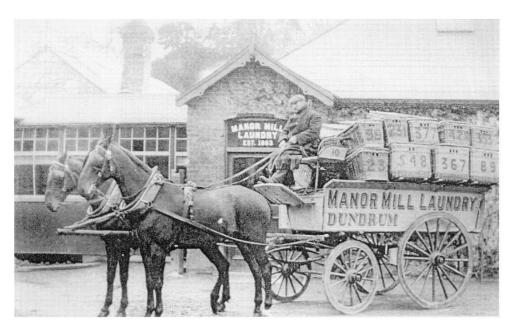

Manor Mill Laundry, *c.* 1910. (Courtesy of Irish Historical Picture Company and Dún Laoghaire-Rathdown County Council)

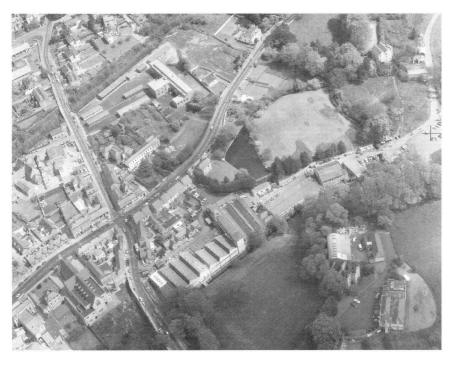

The Pye Centre is near the centre bottom of this aerial photo, taken on 10 May 1971. The wedge-shaped mill pond is clearly visible. Note also Dundrum Castle House at lower right, and the adjacent ruined castle beside a farmyard. (Courtesy of National Library of Ireland)

BRANCH OFFICES:

202, RATHMINES ROAD LR.
141, LR. BAGGOT STREET.
165, LR. DRUMCONDRA ROAD.
370, NORTH CIRCULAR ROAD.
90, RANELAGH.
49, U^{PR} GEORGES ST., DUN LAOGHAIRE.
16, QUINSBORO' ROAD, BRAY.
48, CASTLE STREET, DALKEY.
111, EMMET ROAD, INCHICORE.
6, MERRION ROAD, BALLSBRIDGE.

3 NOV 1961

The
DUBLIN

LAUNDRY CO. LTD

M I L L T O W N
D U B L I N · S.4X 6

TELEPHONE 96681

2nd November, 1961.

In view of the general preference the hours of work on and after

Monday, November 6th will be:-

MONDAY	9 a.m. to 6 p.m.
TUESDAY, WEDNESDAY & THURSDAY	8 a.m. to 5.30 p.m.

1961 letterhead of the Dublin Laundry, Milltown, beside the Nine Arches bridge. The redbrick chimney stack is all that now remains. (Courtesy of Irish Labour History Museum)

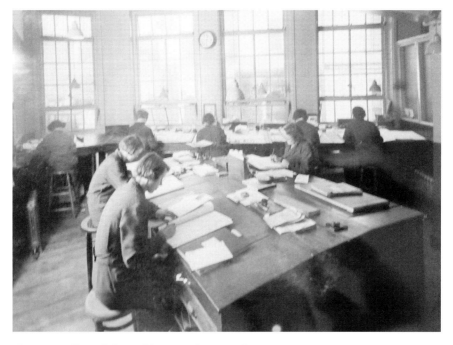

The main office of the Dublin Laundry in Milltown, 1936. The Manor Mill Laundry would have been run along similar lines. (Courtesy of National Archives)

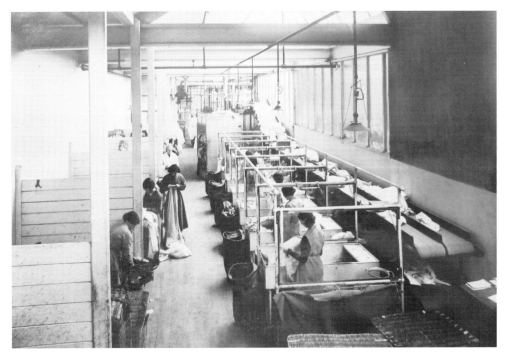

Dublin Laundry in 1936 – sorting the newly arrived baskets of dirty clothes. (Courtesy of National Archives)

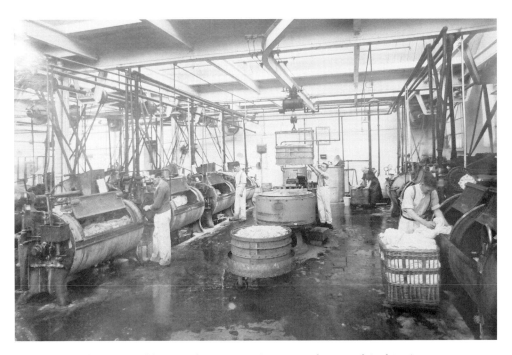

The washhouse in Dublin Laundry in 1936. (Courtesy of National Archives)

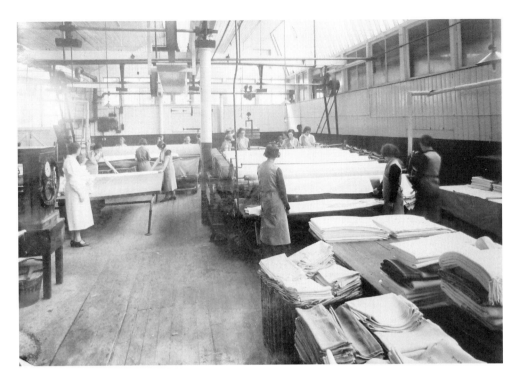

Ironing room for sheets and tablecloths in Dublin Laundry in 1936. (Courtesy of National Archives)

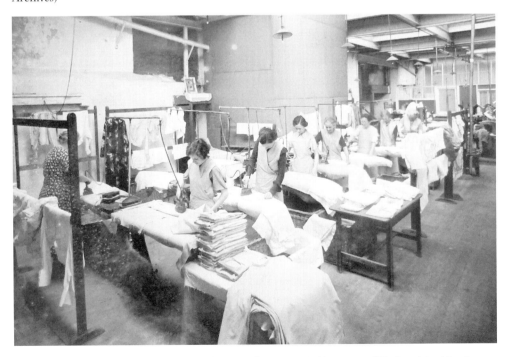

Ironing room for smaller items in the Dublin Laundry in 1936. (Courtesy of National Archives)

Part of the former Pye factory, 1999. The block on the right was used for nearly ten years as Dundrum Bowl (tenpin bowling alley). Pembroke Cottages are on the left.

Inside of Dundrum Bowl in 1992.
(Courtesy of Sean Kennedy)

The west retaining wall of the former mill pond, 1999. This stone wall has been preserved as part of a new pond at the northern end of Dundrum Town Centre, and features jets of water sometimes synchronised with music.

The former Pye factory in 1999. The concrete retaining wall on the right conceals the former mill pond.

The former Pye factory in 1999. The mill pond is behind the stone wall on the right. The stone building on the left was part of the original Manor Mill Laundry.

The former Pye factory in 1999. The building on the left was the offices. Pembroke Cottages are on the right.

The rear part of the former Pye factory, occupied by a variety of small businesses, including Royale Fireplaces, 1999.

1998 photo of the old mill pond in the Pye complex, looking towards the Manor Mill House – the two-storey extension dates from the 1890s. (Courtesy of Burke Kennedy Doyle, Architects for the Dundrum Town Centre)

Sandyford Road, looking towards the Manor Mill House, 1998. The mill pond is behind this stone wall. Roly Saul restaurant now occupies the old house. (Courtesy of Burke Kennedy Doyle, Architects)

Sandyford Road, with Ashgrove apartments on the left, and the Manor Mill House on right (with gable advertising board), 1999. Treacy & Thomas, decorators, were on the immediate right, in premises formerly occupied by Mellons Garage.

1954 letterhead for the Pye factory. The company was based in Cambridge, England, and chaired by Charles Stanley. (Courtesy of National Archives of Ireland)

Pye advertisement in the *Irish Independent*, 1955. Nineteen guineas was £20 in those days. The original guinea coins used gold mined in Guinea, Africa. (Courtesy of Dublin City Library & Archives)

Pye lands, as seen from Castlebrook housing estate, 1999. The old Pye factory is at top left.

2001 photo of Pye lands, with the former Super Crazy Prices at rear left, and Castlebrook houses at rear right. The site overlay pure granite, which was blasted out and crushed in the rock-breaker at lower right, for re-use.

The south end of the Dundrum Town Centre site was occupied by Super Crazy Prices supermarket, which was built originally as a new Pye factory. Wigidors paint and wallpaper shop was alongside the supermarket, and Hafners sausage factory occupied another part of the vast former factory. (Courtesy of Burke Kennedy Doyle, Architects)

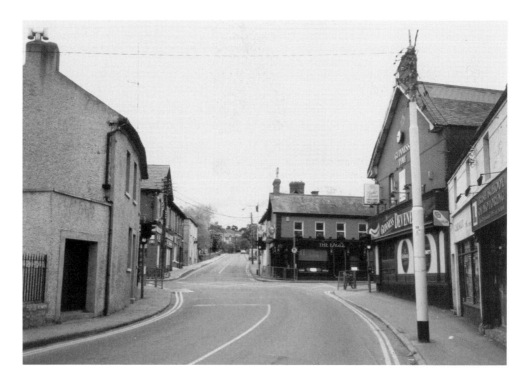

Rural tranquillity in 2002,when Ballinteer bridge was being reconstructed as Dom Marmion bridge. Campbell's is on the left and Deveneys off-licence on the right.

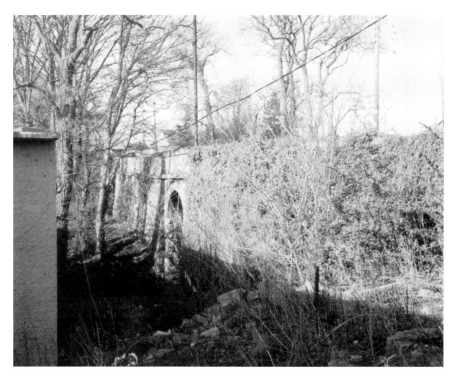

The old single-arch Ballinteer bridge over the River Slang in 1999.

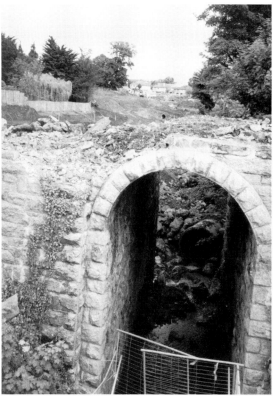

The semi-circular stilted-arch bridge on the Ballinteer Road during demolition to make way for the Dom Marmion bridge.

The basement of the former Dundrum Bowl (Pye factory), with stone retaining wall supporting the Pembroke Cottages.

The Dundrum Town Centre under construction, from the Dom Marmion Club car park, with Holy Cross Primary School on the right, 2004.

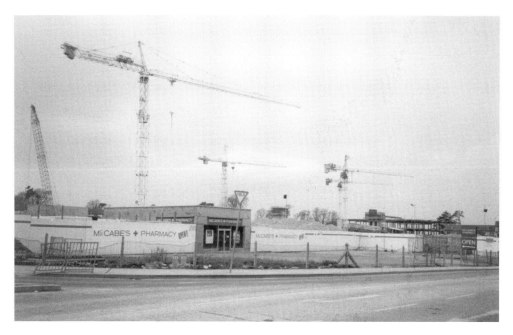

Colette Loughman Pharmacy was inside the original Super Crazy Prices supermarket, and was taken over in 2002 by McCabes Pharmacy chain. During the building of Dundrum Town Centre, they were housed in a specially built temporary premises alongside the Sandyford Road, so that Colette and her colleagues could continue to service their local customers. Now McCabes occupy a unit inside the new centre.

The army and Garda provided an escort every Wednesday when explosives were brought to the site for rock blasting. Note McCabes Pharmacy on top of the granite embankment.

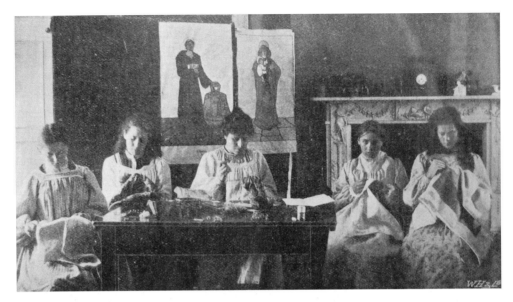

Lily Yeats, in centre, surrounded by young girls, in the embroidery workshop in 1903, based in Dun Emer House. (Courtesy of Trinity College Dublin)

Lolly Yeats in 1903 at the printing press in Dun Emer House. (Courtesy of Trinity College Dublin)

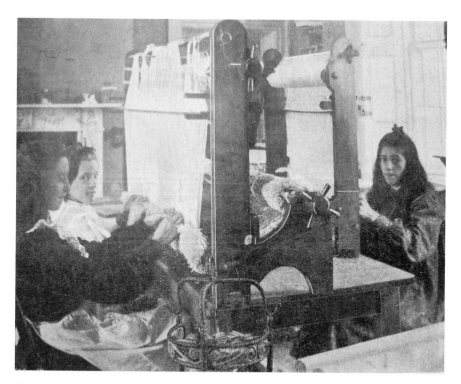

The upright loom for rug-making and tapestries in Dun Emer House in 1903. Evelyn Gleeson was in charge of this department. (Courtesy of Trinity College Dublin)

The Bible scene 'Woman at the Well', one of four exquisite embroidered pictures by Lily Yeats, behind the altar in St Nahi's church.

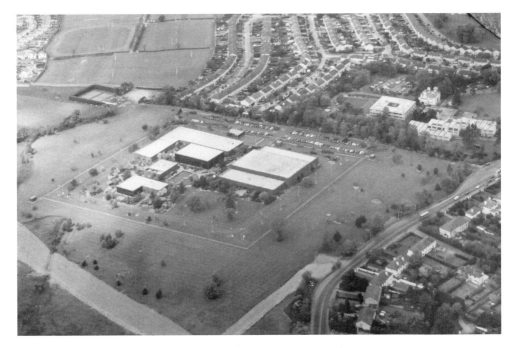

Aerial photo of the Central Bank Mint on Sandyford Road, *c.* 1980. The Irish Management Institute is located at top right. (Courtesy of the Central Bank)

'Female Figure and Tree', sculpted by James McKenna in 1979, in one of the lovely landscaped courtyards of the Central Bank Mint.

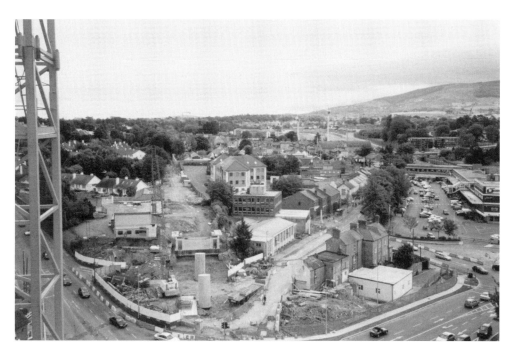

On the right is the original Dundrum Shopping Centre in 2002, and on the left is the new Luas tramline under construction along the route of the old Harcourt Street Railway Line

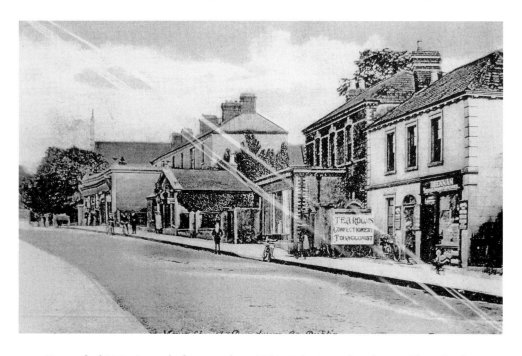

Postcard of Main Street, looking south, *c.* 1910. Holy Cross church is visible in the distance, just past Saunders Drapery (later Mulveys). (Courtesy of Irish Historical Picture Company and Dún Laoghaire-Rathdown County Council)

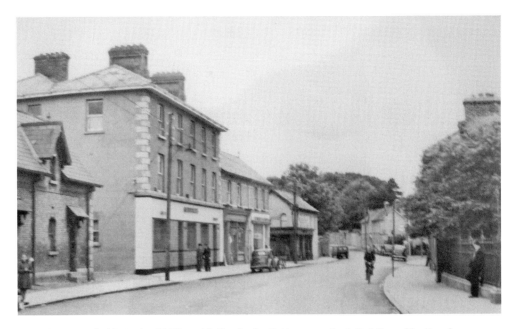

Main Street, probably in the 1950s, with Pembroke Cottages on the left, followed by Dundrum House pub, and the Eagle House pub at the far corner. Holy Cross church railings are on the right, and in the distance is Mellons Garage and cars parked outside, followed by Manor Mill House. (Courtesy of Kathleen Kinch)

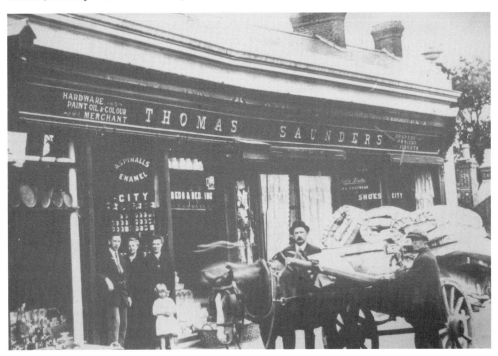

Saunders Drapery (later Mulveys), *c.* 1910. (Courtesy of Irish Historical Picture Company and Dún Laoghaire-Rathdown County Council)

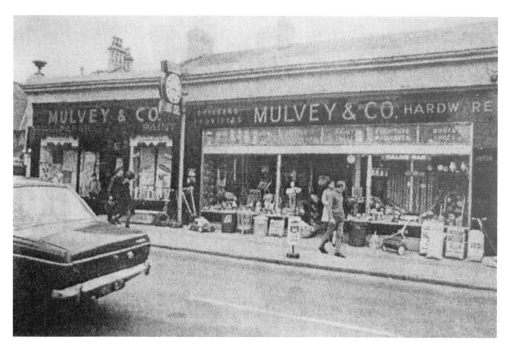

1970s view of Mulveys. The wing on the left was later demolished to provide the present ramp down to the builders providers yard. (Courtesy of John Mulvey)

Mulveys yard, with the new by-pass under construction, 2001.

Campbell's Shoe Repairs in the 1980s. (Courtesy of Paul Campbell Senior)

The genial Paul Campbell, July 2004. He is still beavering away today on selected weekday afternoons.

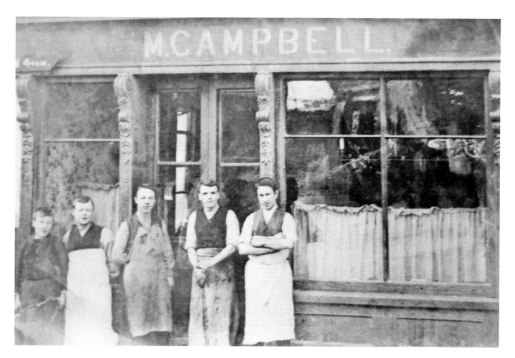

Campbell's Shoe Repairs, Mahers Terrace, Main Street, *c.* 1910. (Courtesy of Paul Campbell Senior)

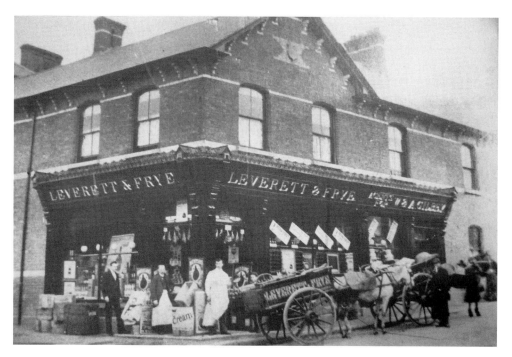

The upmarket Leverett & Frye grocery shop, which was directly across from Campbell's Shoes, *c.* 1910. (Courtesy of Paul Campbell Senior)

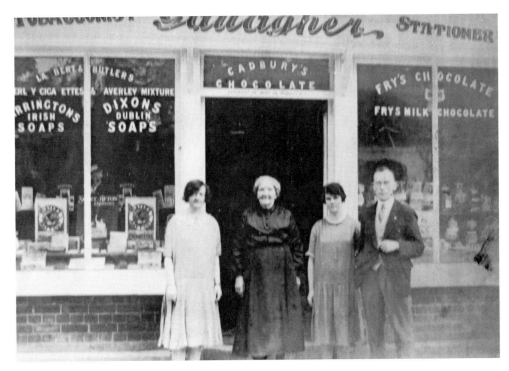

Gallagher's tobacconist and stationers on Main Street, around the present site of AIB Bank. (Courtesy of Paul Campbell Senior)

The famous Findlater's grocery store was at 14 Main Street ('Waverley') and closed in 1969. (Courtesy of Alex Findlater)

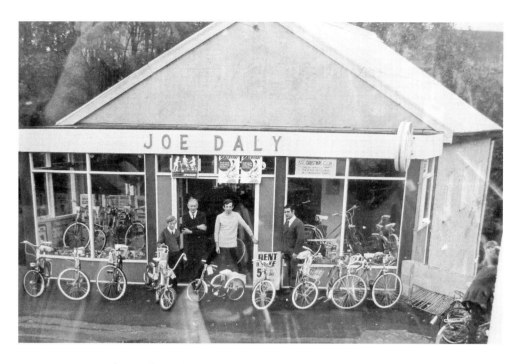

1960s view of Joe Daly and sons. This was their new premises, a short distance north of the original shop. (Courtesy of David Tansey-Daly)

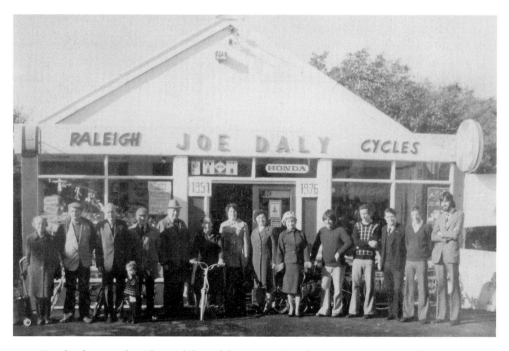

Family photo at the Silver Jubilee celebrations. Note the Pye sign on the right. (Courtesy of David Tansey-Daly)

Rosemount (south of the Apollo building), 1996. Joe Daly Cycles is on the right, with Keegans to its left, then Barney Rooney, and then the original 1951 Joe Daly shop behind the trees. (Courtesy of David Tansey-Daly)

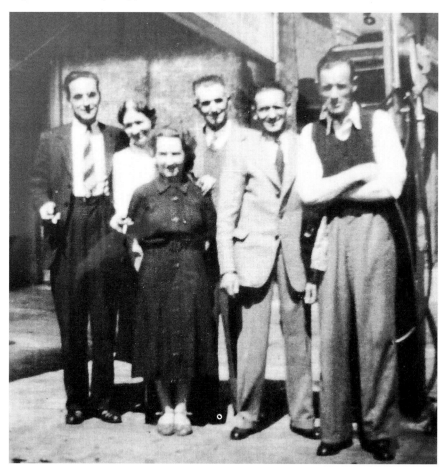

Joe Daly with the Mellon family in the late 1940s outside Mellons Garage on the Sandyford Road (opposite the side of the Eagle House pub), where Joe spent seventeen years as a mechanic. Note the Esso petrol pump at the footpath kerb. (Courtesy of David Tansey-Daly)

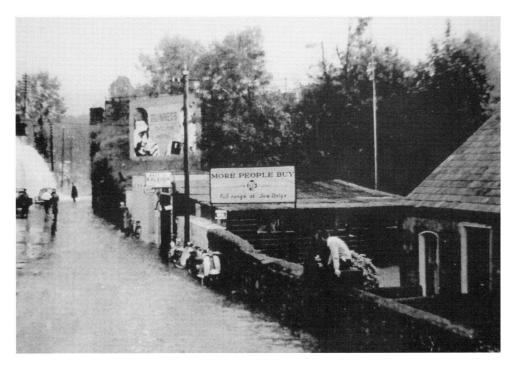

June 1963 flood in Rosemount. Joe Daly's flat-roofed shop was badly hit, especially the basement. The railway bridge had been demolished by this date, and rainwater from the former train track can be seen on the left cascading down onto the road. (Courtesy of David Tansey-Daly)

The legendary cyclist Stephen Roche hails from Dundrum, and in his honour, the Tour de France started on Dundrum Main Street in 1998. This excellent granite wheel is positioned beside Roly Saul restaurant, and echoes the former millwheel on the River Slang.

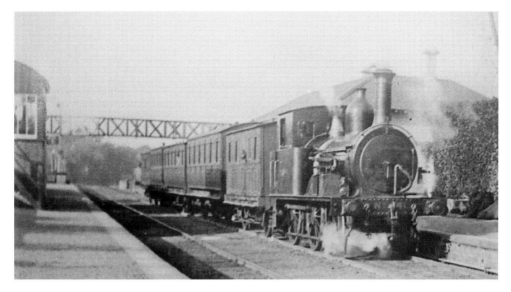

Steam train in Dundrum station with the main station building in the background, *c.* 1878. (Courtesy of Irish Railway Records Society)

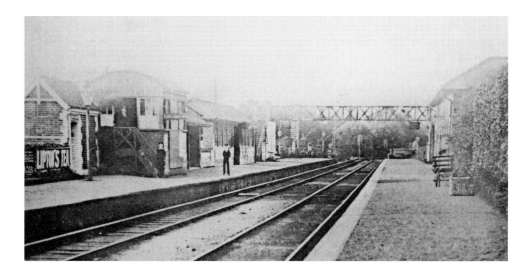

Dundrum station, *c.* 1878. The main station building is on the right. (Courtesy of Irish Railway Records Society)

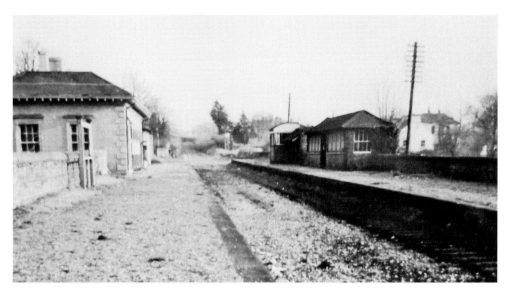

The abandoned Dundrum station, looking south (above) and north (below). The track has been removed, meaning the images probably date from the 1970s. (Courtesy of Irish Railway Records Society)

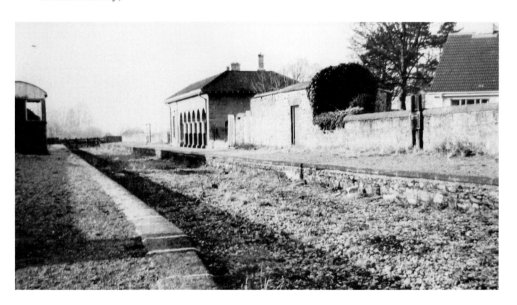

Dundrum Main Street, *c.* 1950. The road running towards Dublin narrows under the iron railway bridge. Ushers monument/obelisk has pride of place. (Courtesy of Irish Historical Picture Company and Dún Laoghaire-Rathdown County Council)

2001 view of Taney Road/Churchtown Road junction, before the William Dargan cable-stayed Luas bridge was built.

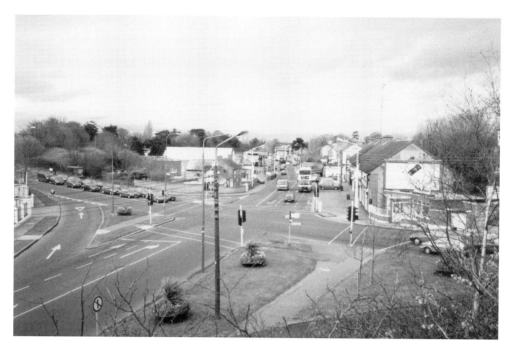

Taney Road crossroads in 1999, before the massive Luas cable-stayed bridge dominated the low-rise landscape. The building on the right (now St Vincent de Paul and Dundrum Stationery) was the Astor Ballroom.

Main Street/Churchtown Road junction, 1999.

Rear of Waldemar Terrace in 1999. Main Street is along the left.

The front of Waldemar Terrace in 1999, with the Carnegie Library on the left. The pair of semi-detached houses was demolished shortly afterwards to make way for the Dundrum by-pass.

Usher House in 1999. Later, an extra storey was added and the exterior re-clad. The Telephone Exchange is on the left.

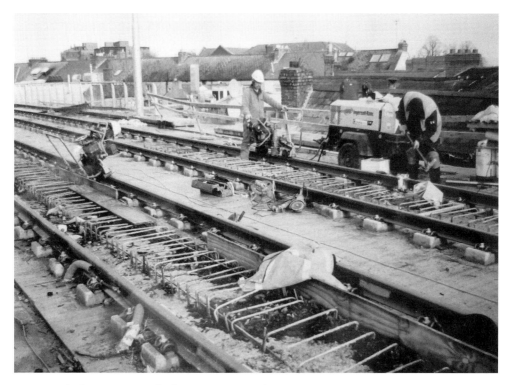

Ranelagh in 2002, with the construction of the Luas tramline. Special welding machines joined the long lengths of steel tracks.

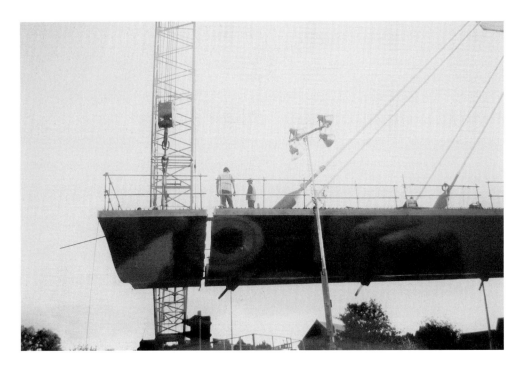

Above and below: Construction of the Luas cable-stayed bridge in 2002. All the roads remained open, and each small section of pre-cast concrete bridge was positioned by a mobile crane.

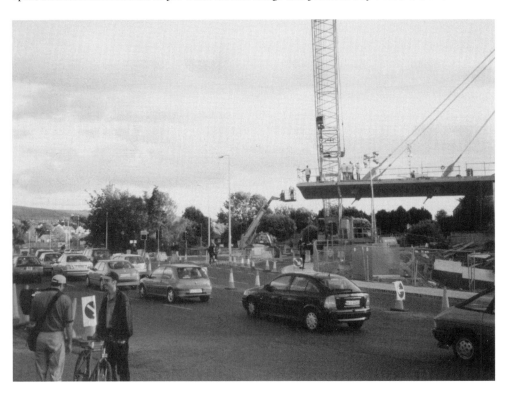

The author near the top of the concrete pylon during construction of the Luas bridge in 2002, seeking the perfect 'bird's-eye view' of the village.

The completed Luas bridge. Carnegie Library can be seen on the left, and Notre Dame at rear left.

A cross-section of the Luas curved bridge deck, 2002. 'Graham' was the specialist bridge builder from Northern Ireland.

Michael Clarke in the yard behind Waverley, 14 Main Street, with Philomena Clarke (daughter of his brother Jim). The lovely car in the background belonged to Michael Connor, who worked in the piggery in the back garden. Nowadays, the garden and outbuildings are still intact, providing a peaceful 'oasis' off the busy Main Street. (Courtesy of Jim Clarke, who still resides here)

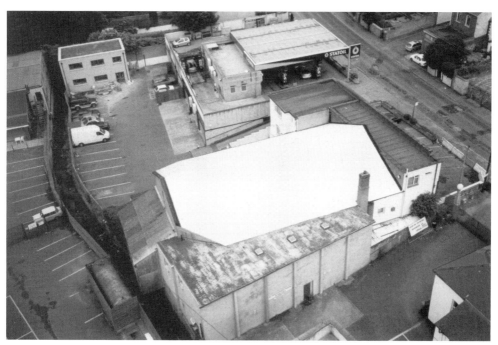

Bird's-eye view of the Apollo Building (formerly Odeon Cinema) building in 2002, with the River Slang on its left.

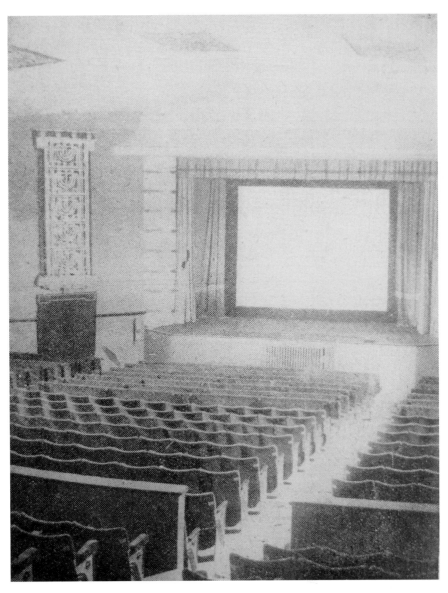

Interior of the new Odeon Cinema in 1942, featuring 'Hiltonia' tip-up luxurious seating. (Courtesy of National Library)

The circus often set up the 'big top' in the car park of The Goat pub, seen here in August 2002.

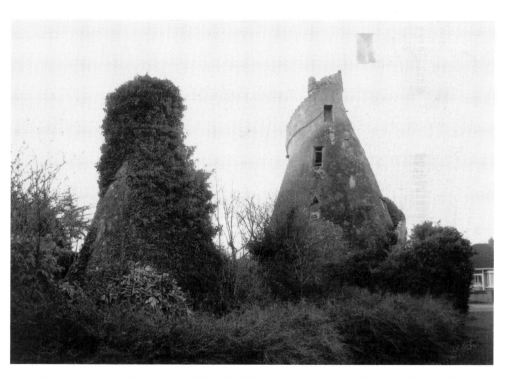

There are two 'bottle towers' in Whitehall Road in Churchtown, although the smaller one is barely visible to passers-by. They were built by Hall in the 1750s to store grain, and known then as Hall's barn.

Also from The History Press

Dublin

Leabharlanna Poibli Chathair Bhaile Átha Cliath
Dublin City Public Libraries